IMAGES
of America

WEST VIRGINIA PENITENTIARY

ON THE COVER: An armed guard maintains order and keeps a careful watch over the inmates' activities from one of the prison's towers located at the corner of Eighth Street and Washington Avenue. (Courtesy of the West Virginia State Archives.)

IMAGES
of America

WEST VIRGINIA
PENITENTIARY

Jonathan D. Clemins

ARCADIA
PUBLISHING

Published by Arcadia Publishing
Charleston, South Carolina

Printed in the United States of America

Library of Congress Control Number: 2009935948

For all general information contact Arcadia Publishing at:
Telephone 843-853-2070
Fax 843-853-0044
E-mail sales@arcadiapublishing.com
For customer service and orders:
Toll-Free 1-888-313-2665

Visit us on the Internet at www.arcadiapublishing.com

For my bride, Sarah, with all my love.

CONTENTS

ACKNOWLEDGMENTS

Firstly, I would like to extend my sincere appreciation and thanks to the Moundsville Economic Development Council for all of their help. I commend each of you on the work that you do to keep the penitentiary alive, as it is truly a majestic place.

I would also like to individually thank Jessica Nuckels, Jane Skeldon, Suzanne Skeldon, Jason McKinney, and Jackson Fox for joining me on our "exclusive" overnight stay at the penitentiary. It certainly would not have been the same without you. More importantly, on behalf of each of us, we extend our immeasurable gratitude to Tom Stiles for coordinating our stay; thank you very much for all of your stories, knowledge, and kindness.

I would also like to recognize everyone at the *Charleston Gazette* for giving me access to the archives. Additionally, I would like to thank the West Virginia State Archives for accommodating all my requests. I deeply appreciate the assistance that was given to me.

I would also like to thank my family, especially my parents. I love you both and am immensely grateful for all that you do. In addition, I would like to thank Jeanette and Kenneth for taking such good care of me for the past five years.

Finally, I would like thank those who are reading this book. I hope you enjoy the lively history of this fascinating prison as much as I do!

FOREWORD

As a lifelong resident of Moundsville, West Virginia, I grew up with the West Virginia Penitentiary just blocks away from my home. The Gothic-style stone structure encompassed 10 acres of ground and housed the "worst of the worst" inmates in the state.

I remember as a young boy driving by the prison with my father and his telling me, "If you don't change your ways, you'll end up in there someday." He couldn't have been more right. Luckily, I ended up on the right side of a cell door. I was employed by the West Virginia Division of Corrections for 25 years. I worked in the delivery of health care services for 16 years and then served as a deputy warden, a warden, and lastly the commissioner of corrections. In all of these job capacities, I witnessed life within a prison on a daily basis.

The prison stood like a fortress in the middle of town, and while it was a constant sign of punishment for wrongdoing, it was at one time one of the largest employers in the area. The good found within the walls of the prison was seen through the many educational, vocational, and rehabilitative programs provided the inmates. The good, however, sometimes went unnoticed and was overshadowed by news of a riot, escape, or other newsworthy event.

During its 129-year existence, the prison told a story of life behind bars. It told of the good, the bad, and the ugly. At its closure in 1995, the Moundsville Economic Development Council was approved for a 25-year lease of the prison from the West Virginia Division of Corrections. With the signing of the lease, the prison was reopened as a tourist attraction, and to this day, it offers historical and educational tours for the public.

Although many articles have been written about the facility, through his research into the history of the West Virginia Penitentiary and his genuine interest in the prison itself, Jonathan Clemins has been able to tell the story of life at 818 Jefferson Avenue, Moundsville, West Virginia, from a different perspective.

Hopefully, as you read Images of America: *West Virginia Penitentiary*, you too will gain new insight.

—Paul Kirby
Moundsville Economic Development Council Manager and
Retired Former West Virginia Commissioner of Corrections

INTRODUCTION

The concept of a penitentiary is a system inspired by the Quakers that would employ prisoner isolation and promote labor. This system was developed largely in response to social changes that were moving away from corporal punishment and toward incarceration. The idea was to shift the focus from punishing the body to punishing the mind in hopes of generating penitence from the offender, hence the term penitentiary.

In 1863, the newly formed state of West Virginia lacked a penal institution to house convicted felons, and Gov. Arthur Boreman, the state's first governor, was perfectly aware of this predicament. Accordingly, in 1863, during the state's first legislative session, Governor Boreman requested for the planning and construction of a state penitentiary. Ultimately evading Governor Boreman's request, the legislature granted him permission to transfer state felons to prisons outside of the state. The idea was problematic and failed.

Once again in 1864, during the state's second legislative session, Governor Boreman reiterated his request for a state penitentiary. Again, the legislature denied his request; however, the legislature did attempt to accommodate the governor. He was given the opportunity to use the Ohio County jail as a means of imprisonment for state felons. However, the problem was that the jail was simply not designed to operate as a penitentiary. This was made apparent within the first year, as nine inmates escaped and were not recaptured. As the escapes continued, the public began to fear for their well-being. It was apparent that something needed to be done.

At the persistence of Governor Boreman, during the state's fourth legislative session in 1866, the legislature accepted his repeated request. The State Board of Public Works was authorized to purchase a site and develop a plan for the penitentiary, which was to be built using convict labor. However, there was controversy surrounding the placement of the penitentiary, and there are two sides to this story. According to Peter Boyd in *History of Northern West Virginia Panhandle*, Moundsville was given the opportunity to choose between the penitentiary and the state college, which is now West Virginia University. The story insists that Moundsville selected the penitentiary. This is a widespread misconception, as no such historical documentation exists to support the claim. It is likely, however, that Moundsville was chosen because it was in close proximity to Wheeling, the state's capital at the time.

In July 1866, the West Virginia Penitentiary was officially established. It was merely a wooden structure approximately 24 feet wide and 100 feet long surrounded by a wooden fence 14 feet above ground and 4 feet underground. This structure, seven inmates, and the prison's first warden, George S. McFadden, made up the original state penitentiary. Under the careful watch of Warden McFadden, the seven prisoners were initially used to begin construction on the remainder of the penitentiary. Soon thereafter, an additional 30 prisoners were placed in McFadden's custody. Using hand-cut gray limestone quarried at Wheeling and Grafton, West Virginia, and at Steubenville, Ohio, the inmates worked vigorously on the penitentiary. With the inmates and their labor at

his disposal, McFadden completed the administration building, the north and south cell blocks, walls, and towers in approximately 10 years.

As time passed and the penitentiary began to grow, so did its tribulations. From early on, torture was commonly employed as a form of punishment for inmates. Instruments of torture such as the "kicking jenny" and the "shoo-fly" were used until the prisoner was on the brink of death. This barbaric treatment of prisoners continued for many years, until the prison's brutal techniques were exposed. The newly appointed administration quickly abandoned torture. Perhaps the prison's largest dilemma was its size. At times, overcrowding forced three inmates to share a cell. The close quarters shared by inmates only contributed to the violent nature of the prison.

Inmates were offered an assortment of recreational, educational, and vocational opportunities. It was assumed that these opportunities would suffice as rehabilitative services; however, these programs did not prepare inmates to be reintegrated with society. Providing rehabilitation to inmates was the prison's greatest failure and was a contributing factor to the closure of the penitentiary, along with the unbearably small 5-by-7-foot cells. In 1989, the penitentiary's small cells were deemed "cruel and unusual punishment," which led to the closing of the penitentiary in 1995.

Today, the ominous penitentiary is recognized as a national landmark and is visited by over 100,000 enthralled tourists each year. The history of the retired institution repeats itself each day through the enlightening tours offered by the penitentiary. Additionally, visitors can venture the darkened halls of the prison, which are open to the public for night tours and ghost hunts. During the Halloween season, the penitentiary evolves into the Dungeon of Horrors for those looking for a fright. The penitentiary is continually catapulted into the limelight by popular television series such as MTV's *FEAR*, the Travel Channel's *Ghost Adventures*, and ABC's *Scariest Places on Earth*. The captivating penitentiary tours were listed in Time Magazine's "50 Authentic American Experiences." The penitentiary not only satiates the public's taste for the lurid but also provides law enforcement and correctional officers with a training facility. Each year, the penitentiary draws hundreds of correctional and law enforcement officers to National Institute of Justice's mock prison riot. The training provides officers hands-on experience dealing with rioting inmates under real-life conditions. With the endless amount of events, it is obvious that the Moundsville Economic Development Council works relentlessly to coordinate the activities while keeping the prison's wonderful history alive.

One

PRISON—IT'S A HARD KNOCK LIFE

Please read the following rules and regulations governing the West Virginia Penitentiary closely, as it will provide one with invaluable advice for confinement here at the facility.

Institutional life is quite different than living in the community. It will be necessary for you to adjust your habits in order to satisfactorily live and work in this new situation. You will be under almost constant supervision and your daily life will be governed by the enclosed rules and regulations. The duty of the officials of this institution, under law, is to receive you when you are properly and legally committed, and to keep you within the confines of this institution until you are properly and legally released. These officials are interested in you and are willing to help you help yourself. As quickly as possible you should begin taking part in the vocational, educational, religious and other rehabilitative programs offered to you. You should write home regularly, for your letters will allow you to maintain a closer contact with your family and community. In addition, every inmate is encouraged to make use of his visiting privilege and may be assured that you and your visitors will be treated courteously and with respect. You should strive to do the work that may be assigned to you in a cheerful and efficient manner. The rules and regulations are for your benefit and well-being. They will be uniformly and impartially enforced. Your life here will be as comfortable and secure as you make it. It is the fundamental responsibility of this institution and its management to provide a safe and secure environment in such manner and under such rules and programs that every inmate may have the opportunity to improve himself. It is the intention of correctional administrators to maintain communication with all inmates so that grievances, complaints and suggestions may be objectively considered. In order to operate and maintain this institution in a safe, secure, and orderly fashion certain rules and regulations are required. Obviously, those acts contrary to the criminal laws of this State are also illegal within this institution.

Welcome to the West Virginia Penitentiary.

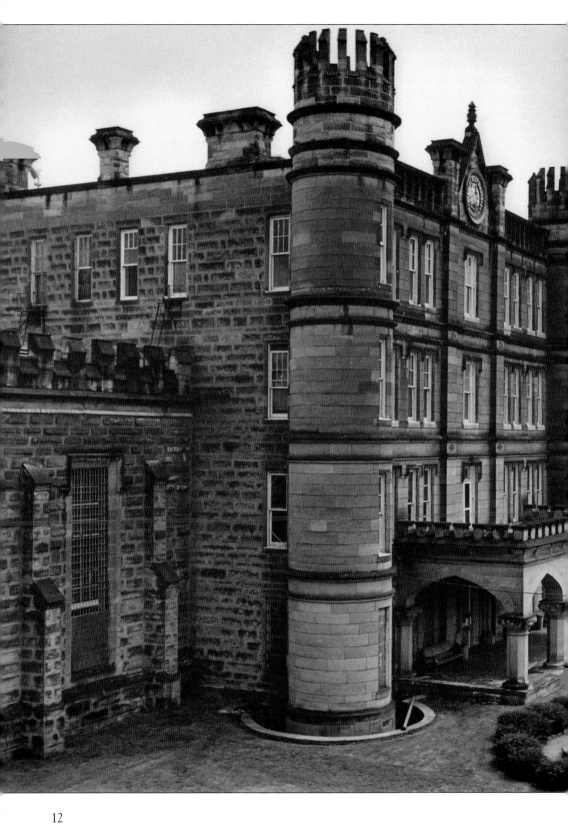

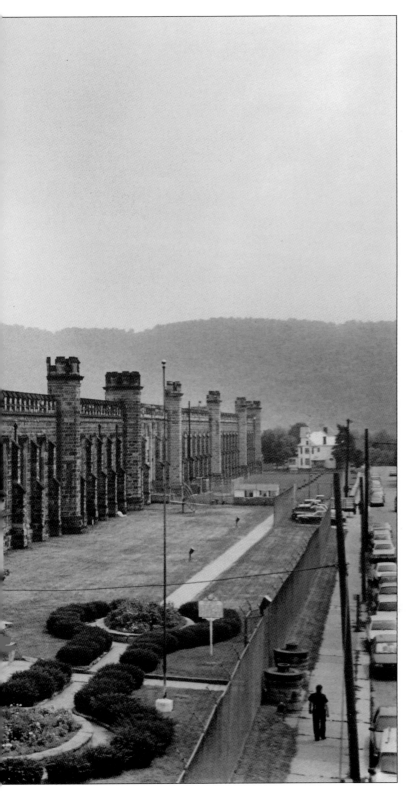

Moundsville, West Virginia, is the home of the imposing and grandiose West Virginia Penitentiary. The penitentiary was modeled after the prison at Joliet, Illinois; decorated in a castellated Gothic architectural style, the turrets and battlements give the penitentiary the appearance of a castle. However, the penitentiary certainly is not a place one may read about in a fairy tale. With the intention to punish inmates for their crimes, the penitentiary employed methods of punishment that would be considered barbaric by today's standards. (Courtesy of the *Charleston Gazette*.)

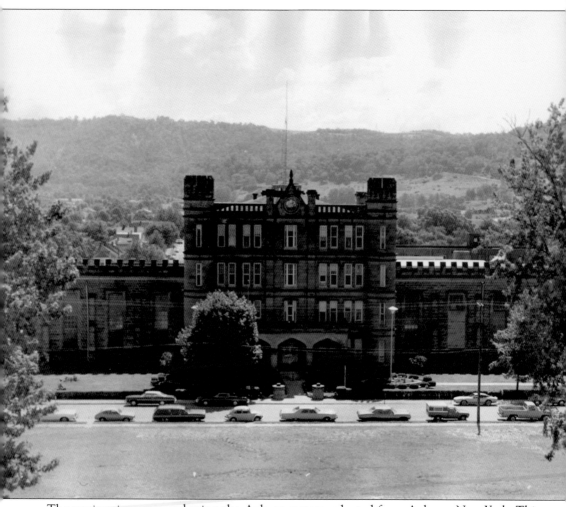

The penitentiary operated using the Auburn system, adopted from Auburn, New York. This system of punishment is also known as the "silent system" and dates back to 1818. This system was selected not because it was thought to be a better form of punishment but because it was more cost efficient. By using the Auburn system, inmates could work together during the day and be separated at night. (Courtesy of the Adkins family.)

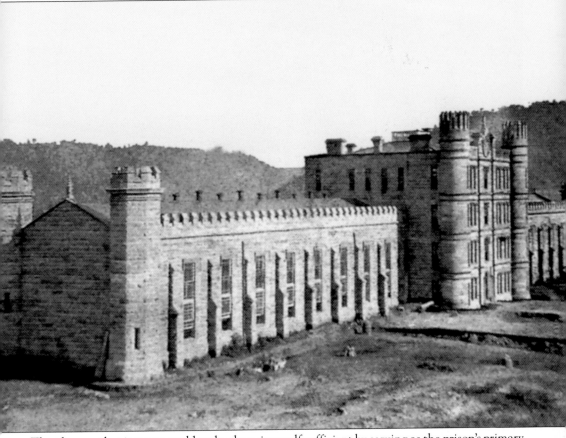

The idea was that inmates could make the prison self-sufficient by serving as the prison's primary source of labor. Since West Virginia was an extremely poor state with a budget of only $1 million during its first decade, the Auburn system would save money compared to the Pennsylvania system, where inmates are separated at all times. This image of the penitentiary dates back to 1876. (Restoration photography courtesy of Robert Schramm.)

Across from the penitentiary lies the largest Adena burial mound in the United States. The Grave Creek Mound was converted into a tourist attraction, and visitors can trek the 69 feet to the top of the mound. There visitors have a stunning view of the penitentiary. (Courtesy of the Moundsville Economic Development Council.)

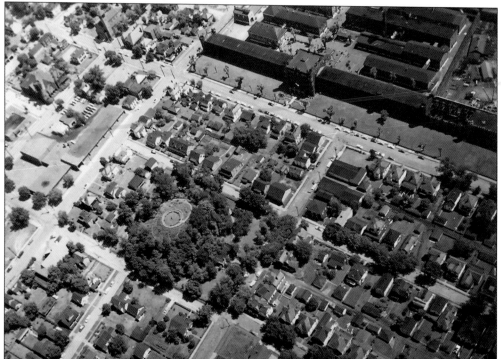

The town of Moundsville essentially grew up around the penitentiary. While it may be unthinkable to many, the majority of Moundsville citizens say they have never been fearful of the nearby penitentiary. (Courtesy of the Moundsville Economic Development Council.)

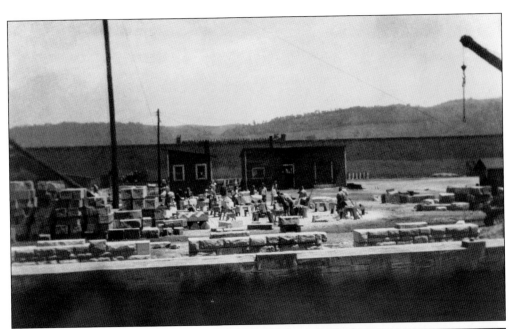

Construction of the penitentiary was the responsibility of inmates. When the prison was established in 1866, West Virginia could not afford to pay for the penitentiary's construction. Accordingly, the State Board of Public Works made it clear that the state would use convicts to construct the penitentiary. (Courtesy of the West Virginia State Archives.)

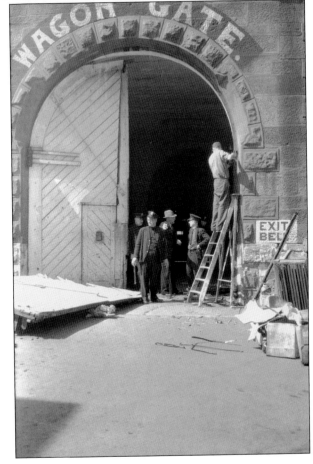

The first structure to stand on penitentiary grounds was the North Wagon Gate. This structure served as an entrance into penitentiary grounds, a housing unit, and gallows for executions. (Courtesy of the West Virginia State Archives.)

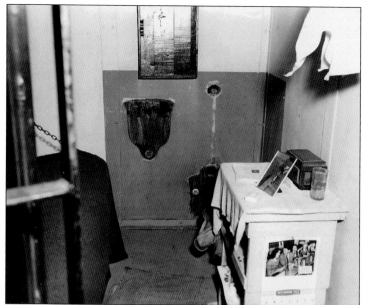

The cells were dreadfully small, merely 5 feet by 7 feet and only 7 feet tall. The majority of the cell's space was occupied by the metal bed, sink, and toilet. (Courtesy of the Moundsville Economic Development Council.)

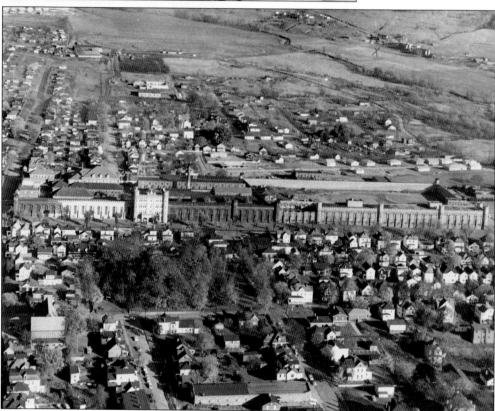

Initially, the prison was built to house 840 male and 32 female inmates; however, in the 1930s, the penitentiary was grossly overcrowded and housed more than 2,700 inmates. It was not unusual for three inmates to share a small, 5-by-7-foot cell. (Courtesy of the Moundsville Economic Development Council.)

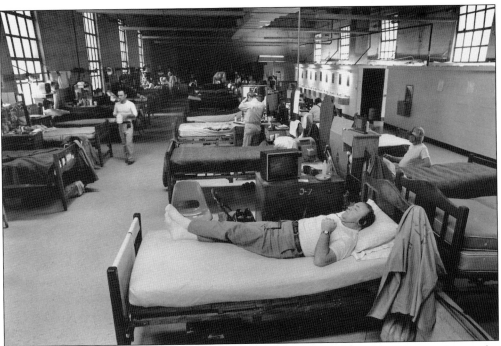

Not all inmates were confined to a small cell. The penitentiary allowed well-behaved men who were 55 and older to stay in the Old Man Colony (OMC). Unlike the small cells, the OMC provided the men with an open living area. (Courtesy of the *Charleston Gazette*.)

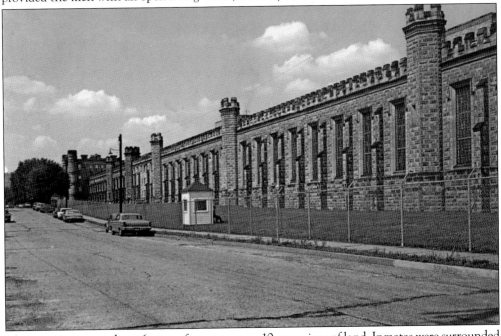

The penitentiary encloses 6 acres of property on a 10-acre piece of land. Inmates were surrounded by a solid wall of hand-cut sandstone measuring 675 feet by 395 feet and 24 feet tall. The base of the wall is 4 feet thick and tapers off to 2 feet thick at the top. (Courtesy of the Moundsville Economic Development Council.)

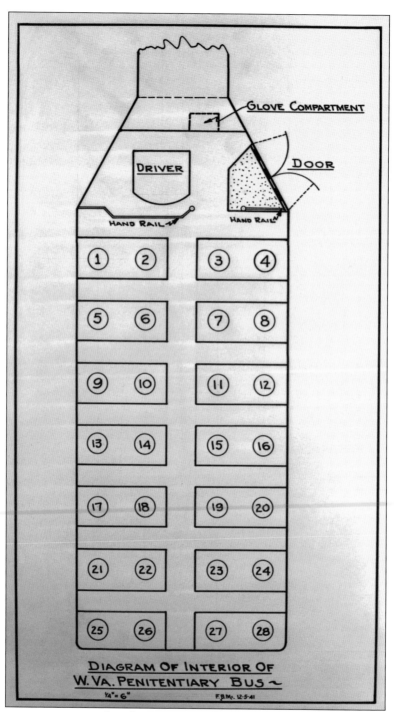

GLOVE COMPARTMENT

DRIVER

DOOR

HAND RAIL HAND RAIL

①	②	③	④
⑤	⑥	⑦	⑧
⑨	⑩	⑪	⑫
⑬	⑭	⑮	⑯
⑰	⑱	⑲	⑳
㉑	㉒	㉓	㉔
㉕	㉖	㉗	㉘

DIAGRAM OF INTERIOR OF
W. VA. PENITENTIARY BUS
¼"= 6" F.B.M. 12-5-41

New inmates were transported to the penitentiary by bus. Once they were off of the bus, they were directed into the penitentiary. While walking into their prison, they were greeted by the overhead state seal with the expression *Montani Semper Liber*, meaning "Mountaineers are Always Free." Perhaps the inmates found the slogan to be ironic considering their situation. (Courtesy of the West Virginia State Archives.)

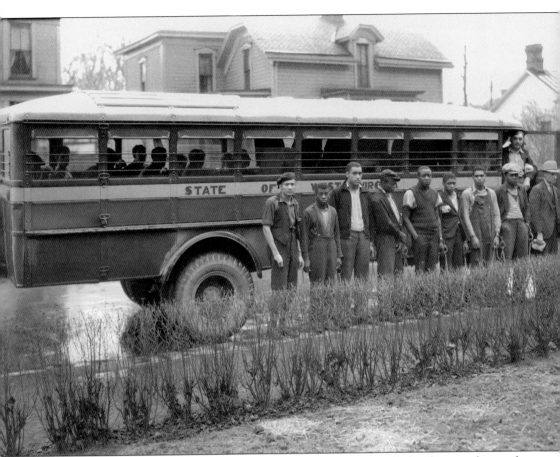

When inmates arrived at the penitentiary, they were immediately enrolled and assigned a serial number. Then the new arrivals were required to bathe, get a haircut, and shave. The inmates were also measured using the Bertillon system, a system similar to phrenology. The inmates were measured based upon 11 categories and filed according to small, medium, and large. Today anthropometric identification is discredited as a biased, racist science and has been replaced with fingerprinting. (Courtesy of the West Virginia State Archives.)

During the early years of the penitentiary, various methods of torture were used to punish inmates. One of the earliest methods of torture employed by the penitentiary was the cat-o'-nine-tails. This whip was made of a minimum of nine cowhide lashes interwoven with wire to cut into the flesh of the victim. The cat-o'-nine-tails was replaced by a leather strap that was soaked in water and then dipped into sand before flogging the inmates. Over the years, many forms of torture were employed freely by the prison. (Courtesy of the Moundsville Economic Development Council.)

In the 1800s, when the prison was still in its infancy, guards tortured inmates using a device the inmates called the "Kicking Jenny." The device was an instrument invented and built in the prison. When it was used, the prisoner was stripped naked and bent over on the device, his hands and feet fastened to the floor. A leather whip was used until the punisher was too exhausted to continue or until the prisoner was on the verge of death. (Courtesy of the Moundsville Economic Development Council.)

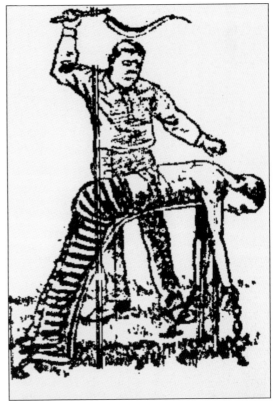

As the needs of the institution grew, so did the penitentiary. In 1929, the prison began the planning process to expand. The proposed idea was to expand the penitentiary to include a southern yard. This project was completed in 1959, and the expansion doubled the area within the prison walls. (Courtesy of the Moundsville Economic Development Council.)

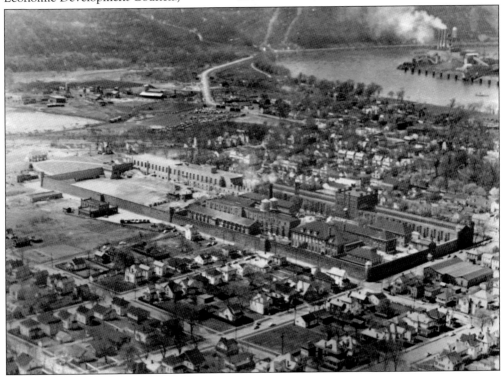

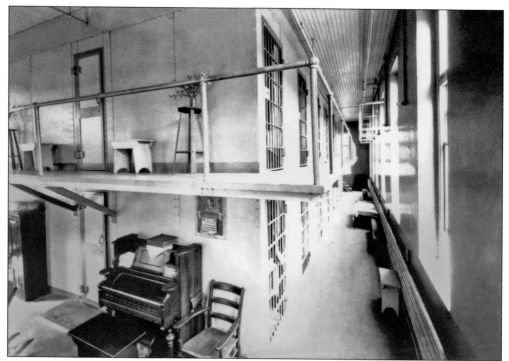

The penitentiary was not limited to male inmates. Female inmates were housed in the third floor of the administration building. The female housing area also had a sewing factory. Women coordinated their work efforts with the men by adding collars and cuffs to the shirts the men made. (Courtesy of the West Virginia State Archives.)

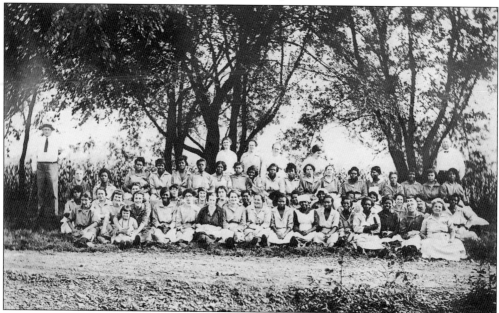

In this photograph, the female inmates pose for a photograph on the prison's lawn. The women were housed at the penitentiary until 1947, when a separate prison for women was established at Pence Springs. (Courtesy of the *Charleston Gazette*.)

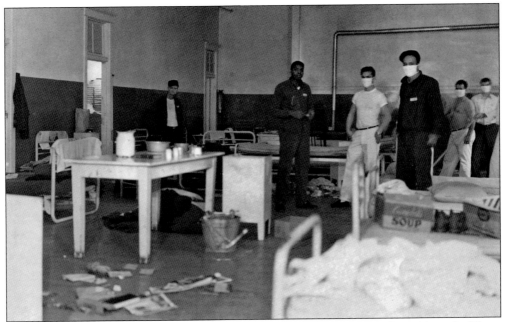

There are essentially five philosophies pertaining to why society punishes criminals. These are deterrence, incapacitation, retribution, rehabilitation, and restoration. The West Virginia Penitentiary's philosophies were evident—incapacitation and retribution. (Courtesy of the Moundsville Economic Development Council.)

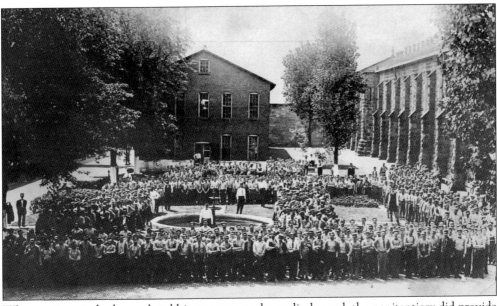

When an inmate had completed his sentence and was discharged, the penitentiary did provide some assistance with integrating the released inmates into the community. The individual was given a new outfit, paid transportation to the county from which he was sent, and a $3 cash allowance for those with no money. However, many inmates who were discharged had several hundred dollars credit in their account. This money was accumulated while working overtime in the prison industries. (Courtesy of Tom Yoho.)

Inmates who were capable of working were required to labor nine hours every day except Saturday afternoon, Sundays, and holidays. The prison had a wide variety of industries to which inmates could be assigned. (Courtesy of the West Virginia State Archives.)

The prison industries helped to relieve the monotony and dangers associated with confinement. While the institution used the majority of the manufactured commodities, there were some unused items. Approximately 116 items were made available to state, county, and city agencies. (Courtesy of the Moundsville Economic Development Council.)

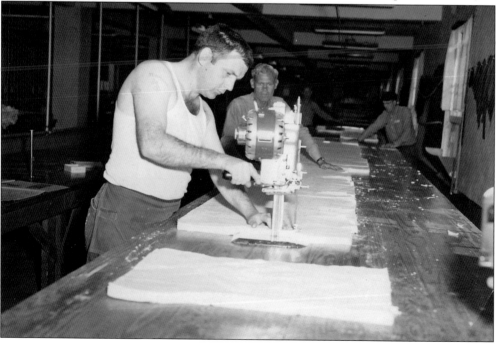

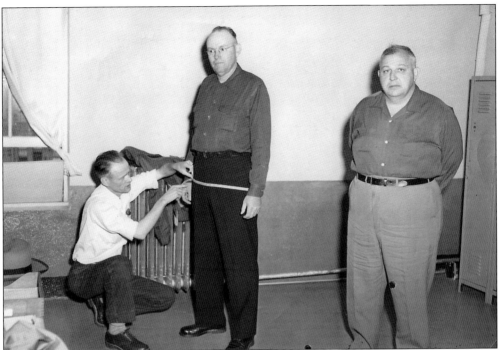

Inmates were used in many facets of work. For example, the inmate in this photograph is measuring two newly hired correctional officers for their uniform. (Courtesy of the Moundsville Economic Development Council.)

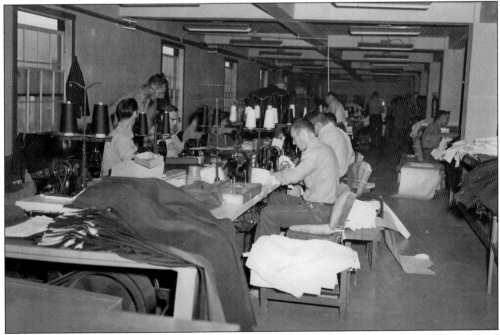

Although the men and women inmates had separate sewing shops, they still coordinated their efforts to make clothing. The men would make the body of the shirts, and the women would make the shirt collars and cuffs. (Courtesy of the Moundsville Economic Development Council.)

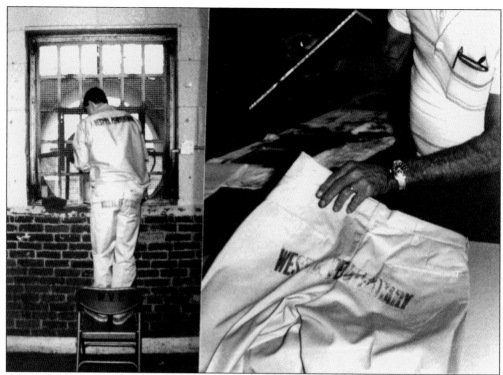

This photograph depicts an inmate working to provide the clothing with a prison stamp. Following the escape of a prisoner and subsequent murder of a state trooper in November 1979, the prison implemented strict guidelines, and inmates were required to wear prison-issued clothing. (Courtesy of the *Charleston Gazette*.)

Many of the inmates assigned to perform work within the city of Moundsville were inmate "trusties." Trusties were well-behaved inmates who had established themselves as responsible, trustworthy inmates, hence the term trusties. (Courtesy of the West Virginia State Archives.)

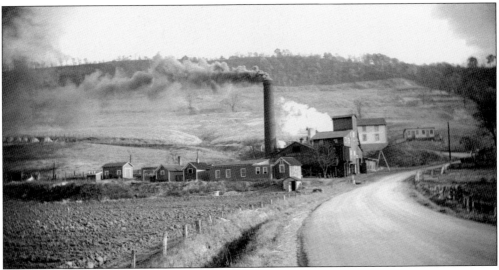

Farming was one of the prison's many industries. The prison owned a farm consisting of over 200 acres. This farm was known as Camp Fairchance and was approximately one mile from the penitentiary. Inmates were responsible for overseeing and maintaining the farm, which provided sustenance for the prison. (Courtesy of the West Virginia State Archives.)

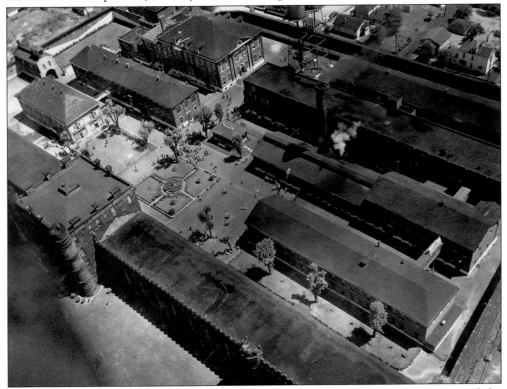

Considering the close proximity of the penitentiary to the Moundsville community and the massive number of escapes, it may seem surprising that many of the citizens living directly across from the prison say they have never feared for their safety. (Courtesy of the Moundsville Economic Development Council.)

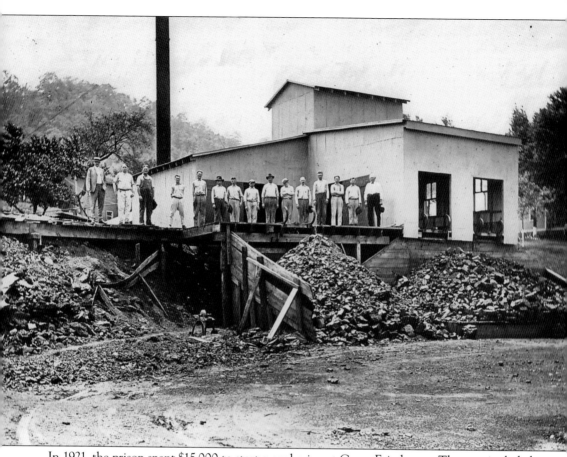

In 1921, the prison spent $15,000 to start a coal mine at Camp Fairchance. The cost included a shaft sunk 80 feet from Sewickley Mine to connect with the Pittsburgh vein. The coal mined by inmate trusties was approximately 14,000 tons annually; this was used as fuel to heat the prison. (Courtesy of the West Virginia State Archives.)

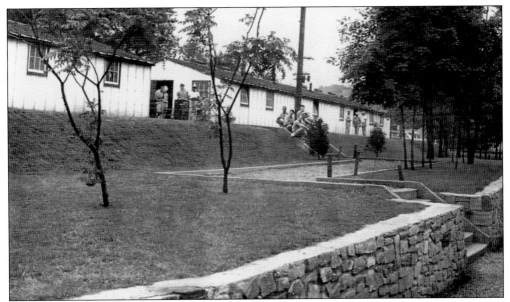

In 1955, housing was established at Camp Fairchance for the inmate trusties who were assigned to work on the farm. Escapes were exceptionally common, approximately one per week. Due to the common escapes, citizens dubbed Camp Fairchance with the nickname "Camp Surechance." (Restoration photography courtesy of Robert Schramm.)

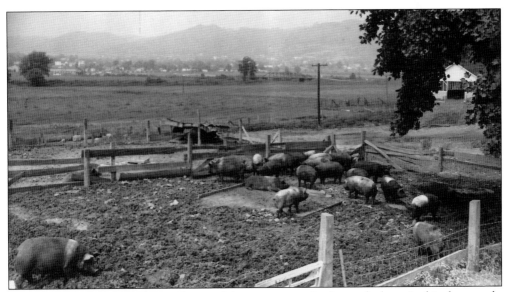

In 1959, a fire at Camp Fairchance destroyed the structure used to house the hogs. In this photograph, the hogs are still without shelter. Nevertheless, new and improved facilities were built within a short time. (Courtesy of the Moundsville Economic Development Council.)

As years passed, the vehicles used by the penitentiary became damaged and would easily break down. During one instance, the penitentiary had to borrow a vehicle from the State Board of Education due to lack of operable vehicles. Eventually, all of the vehicles were repaired by the inmate mechanics. (Courtesy of the Moundsville Economic Development Council.)

Inmates at the institution worked on repairing and restoring vehicles to appear brand new. All of the vehicles restored by inmates were painted a standard color—azure blue. (Courtesy of John Massie.)

When visiting a small community, one of the first things visible is the community's water tank. As the outward appearance of the water tanks in the prison yard continually deteriorated with rust, they leaked and were unsafe. Accordingly, the prison administration ordered them to be drained and repaired by inmates. (Courtesy of the Moundsville Economic Development Council.)

Inmates were not restricted to labor within the confines of the penitentiary grounds. Private businesses could purchase inmates for their labor. In 1874, the cost was less than 16¢ per day. This trend continued until the 1930s, when federal law ruled that purchasing inmate labor was unfair to the community's working population. (Courtesy of the West Virginia State Archives.)

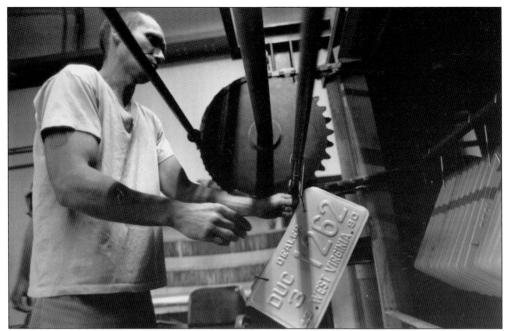

Inmates were used for all types of work. They would make license plates and clothes and repair vehicles, and they were even transported to disaster areas to help with relief projects. In August 1958, inmates boarded a bus headed for Kanawha County to assist with the emergency flood work. (Courtesy of the *Charleston Gazette*.)

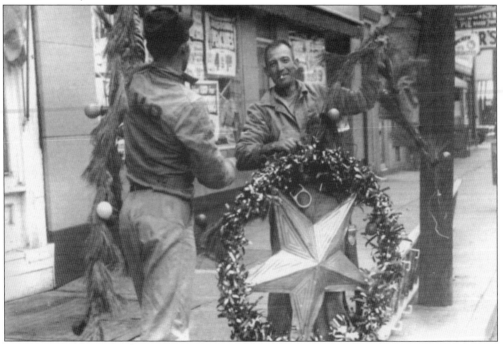

Inmate trusties were used to perform a variety of duties in Moundsville. In this photograph, two trusties are setting up decorations for the holiday season. (Restoration photography courtesy of Robert Schramm.)

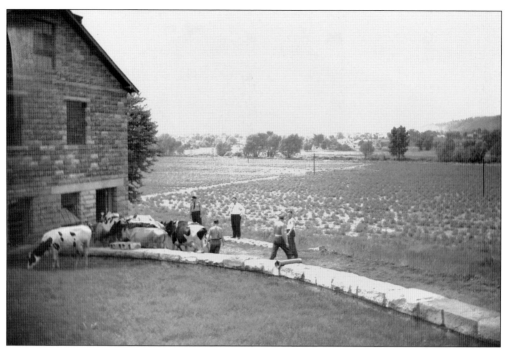

With the seemingly endless amount of prison industries, the penitentiary was not only self-sufficient, but it also earned a profit. (Courtesy of the West Virginia State Archives.)

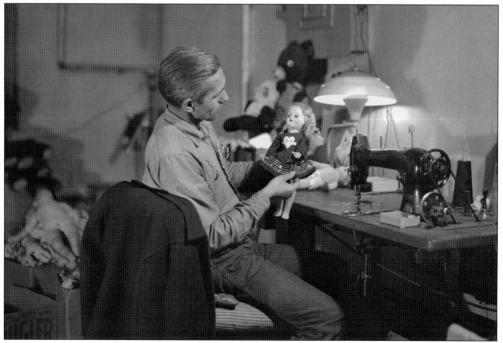

In this image, an inmate works intently to repair a doll for the Toys for Tots program. For several years, the prison dedicated an area within the institution as "Santa's Workshop." Inmates would repair second-hand toys that were donated another boy or girl. (Courtesy of the West Virginia State Archives.)

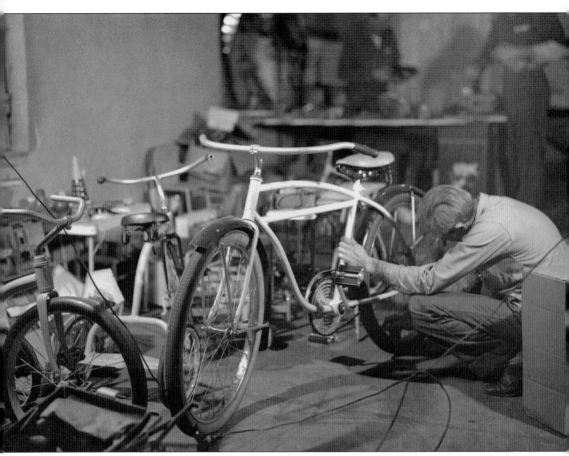

The inmates worked with a great deal of love and care when making the toys for the children. Each year, many bicycles and tricycles were made from old parts and looked brand new when they were completed. Many of the inmates who worked inside Santa's Workshop were fathers and understood the importance of a special toy for a child at Christmas. (Courtesy of the West Virginia State Archives.)

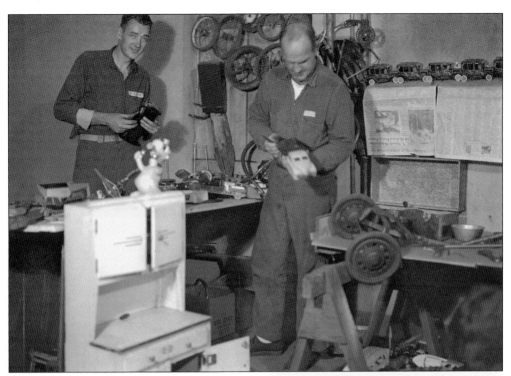

Although the men were inmates of a penitentiary, this does not necessarily imply that they were inherently bad men. Many of the inmates were good men who had made bad choices. Nonetheless, there were men in the penitentiary who would not hesitate to kill, even for the most trivial reasons. (Courtesy of the Moundsville Economic Development Council.)

The penitentiary certainly provided an economical boost to the small Moundsville community, and citizens were aware of the prison's benefits. As such, the community strived to provide each of the inmates at the penitentiary a Christmas gift. (Courtesy of the Moundsville Economic Development Council.)

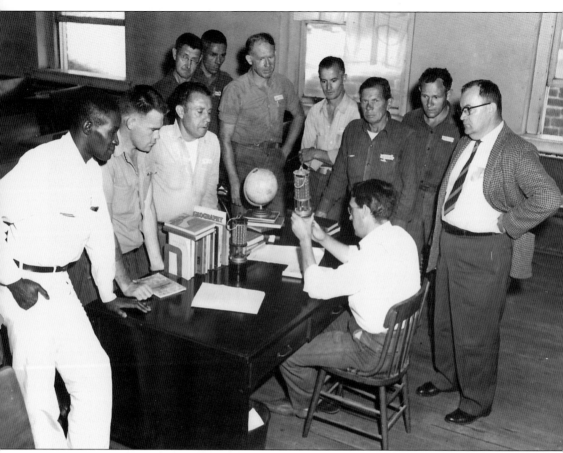

Director of education W. A. Day and a group of inmates attended a mine foremanship class instructed by Larry Browning (seated). A group of 14 inmates attended the class. Although more may have wanted to attend, a prerequisite of five years' mining experience was required. At the end of the course, the students who passed the comprehensive exam received the coveted mine foreman's certificate. (Courtesy of the Moundsville Economic Development Council.)

In this photograph, Day delivers an English lecture to his class of inmate students. For this lesson, Day focused his efforts on teaching antonyms, synonyms, homonyms, and paronyms. Many of the inmates in this class eventually received their high school diplomas. (Courtesy the of Moundsville Economic Development Council.)

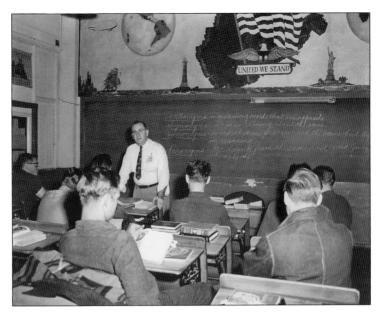

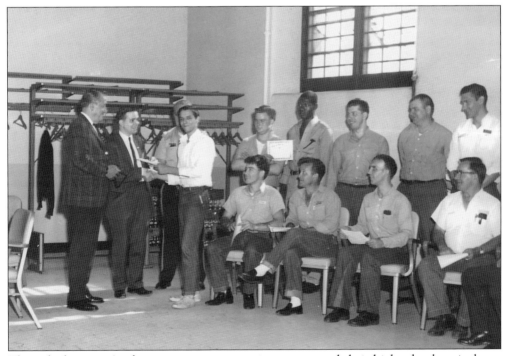

Through the prison's education courses, many inmates earned their high school equivalency diplomas. Eventually, the prison expanded the educational opportunities afforded to inmates and began offering college courses. Many inmates earned college degrees while serving their time. (Courtesy of the Moundsville Economic Development Council.)

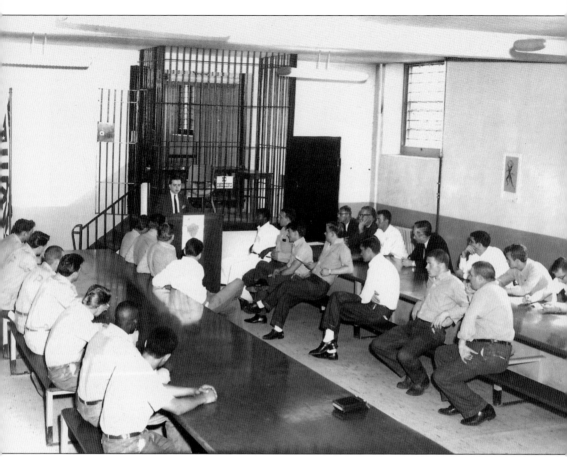

The well-behaved inmates were able to participate in an organization called the Jaycees or the U.S. Junior Chamber. This organization is for individuals between 18 and 41 years old and promotes legitimate means of making a living by providing and promoting management skills, individual training, and community service. This organization was the closest thing that the prison had to a rehabilitative program. Unfortunately, it was only available for a select group of inmates. (Courtesy of the Moundsville Economic Development Council.)

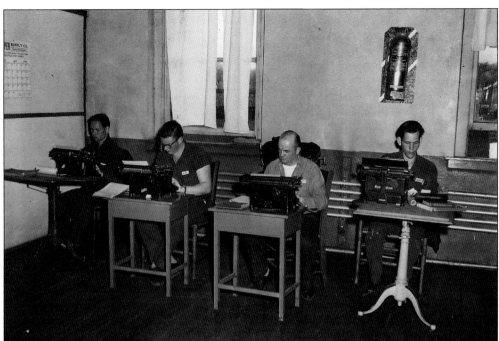

Typing was also offered at the penitentiary and was immensely popular; it was so popular that inmates had to attend tryouts. Candidates for the class were chosen based upon performance, spelling, and clerical aptitude. (Courtesy of the Moundsville Economic Development Council.)

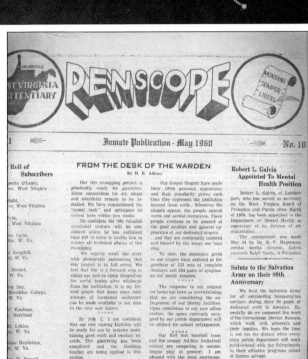

The *Penscope* was a "monthly inmate publication of the West Virginia Penitentiary. Its purpose is to afford the inmates of the West Virginia Penitentiary an outlet for literary expression; to serve as a medium for discussion of inmate and public problems; and to serve as an instrument of information concerning institutional activities." The paper was delivered to the inmates free of charge; however, subscriptions were sold to the public for $1 per year. (Courtesy of Marshall University Special Collections.)

In 1958, the director of education, W. A. Day, recognized all of the talented artists within the penitentiary and realized the need for an art program. Similar to the educational courses taught, art courses would also be taught. When Day announced the courses, the response was overwhelmingly spectacular. (Courtesy of the Moundsville Economic Development Council.)

The humble beginnings of the art department started with a gift from the Salvation Army. In this photograph, Lt. Morris Eads (with bow tie), Day, and three unknown inmates pose with boxes of paints that were donated by the Salvation Army. Eventually, the art department would hold art exhibits that coincided with sporting events. (Courtesy of the Moundsville Economic Development Council.)

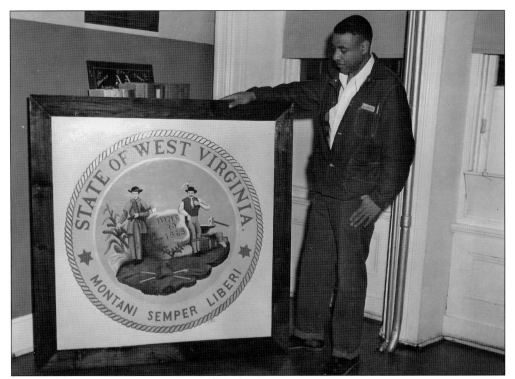

Artist Mirl Martin poses with his 42-inch painting of the West Virginia State seal. The painting was to adorn the office of the secretary of state, Helen Holt. He even painted Gov. Cecil Underwood's face on one of the farmers. (Courtesy of the Moundsville Economic Development Council.)

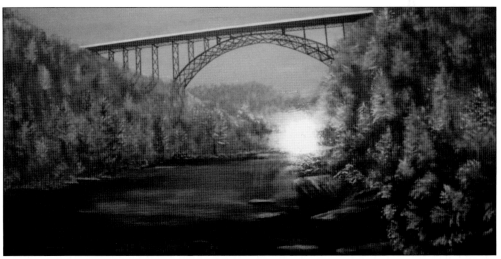

Many of the inmates were skilled artists and would embellish the penitentiary with their artwork. This painting of the New River Gorge Bridge in Fayette County was painted by the Avengers president and influential inmate leader Danny Lehman. Another inmate stabbed Lehman through the eye with a shank. The shank punctured his brain and killed him. (Courtesy of the author.)

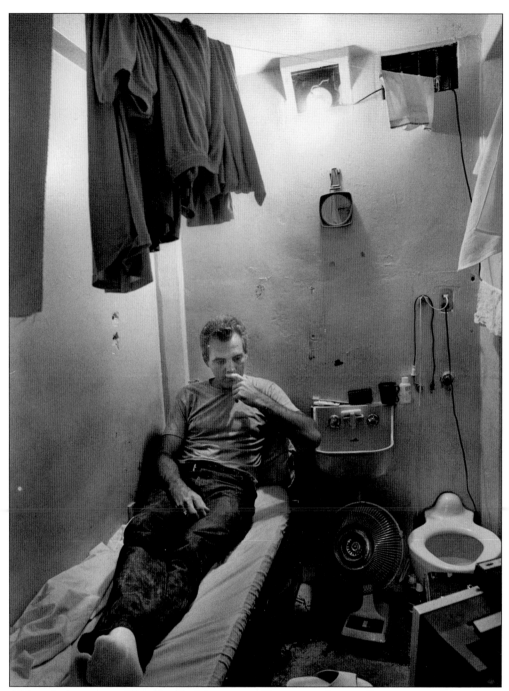

Although classes were offered for the betterment of inmates, only a small percentage of the inmate population could attend the classes. The bulk of the inmate population could barely read, if at all, and some inmates that were able to read could not write. This is the greatest failure of the West Virginia Penitentiary. An individual who cannot read and write has restricted legitimate means by which he can provide for himself and his family. This is the reason why many turn to criminal behavior as a source of income. (Courtesy of the *Charleston Gazette*.)

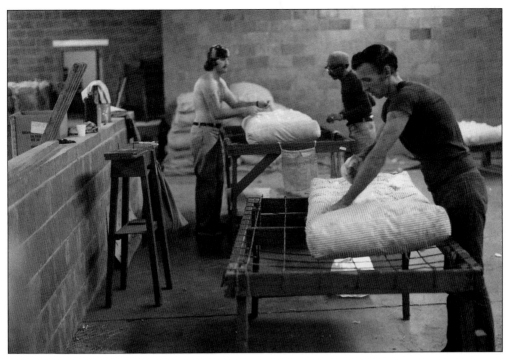

In January 1960, the prison housed 1,806 inmates. Some 73 percent of the prisoners' education level was below the 10th grade, while 1 percent of inmates had received some college education. The most surprising of all is that the prison housed 50 inmates who had never received any type of formal education. (Courtesy of John Massie.)

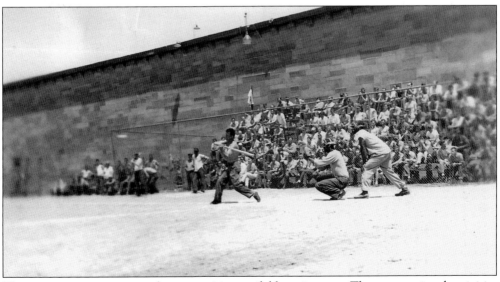

There were many recreational opportunities available to inmates. These recreational activities included baseball, boxing, basketball, and several others. The events were not solely for the purpose of entertaining the inmates; the Moundsville community would also take part in the event as spectators. (Courtesy of the Moundsville Economic Development Council.)

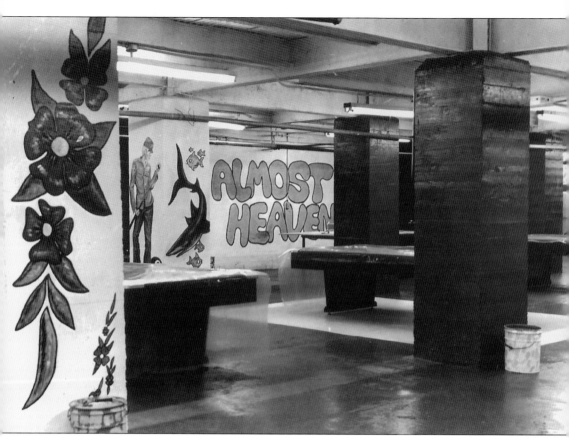

In the event of poor weather conditions, inmates' recreation time occurred in the indoor recreation room, where inmates were unsupervised. Inmates could choose from activities such as pinball, ping-pong, and pool. Many inmates were murdered and sexually assaulted in this area. The sexual assaults were so frequent that the inmates nicknamed this area the "Sugar Shack" due to the inmates who used the time in this area to "get some sugar." (Courtesy of the Moundsville Economic Development Council.)

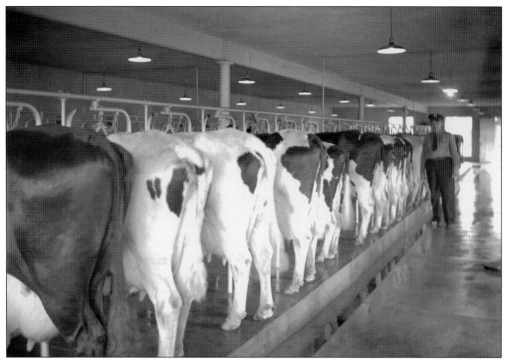

The prison was constantly holding some type of sporting event or concert to help raise money for the penitentiary. With the profits earned, the prison began to build a dairy herd. The prison even purchased the daughter of the Canadian champion milk and butterfat producer. (Courtesy of the West Virginia State Archives.)

It was not always all work and no play for the inmates of the West Virginia Penitentiary. In this photograph, the prison's basketball team, the Moundsville Cougars, is practicing in front of an inmate audience, preparing for a big game. (Courtesy of the West Virginia State Archives.)

In the ninth inning, the Prison Red Sox were trailing the Blaine United Mine Workers at the New Wall Stadium. The Red Sox's Herbie Sewell's hit allowed Tom DeJarnette to run home. The bases were loaded, and Delmus Gregg hit an inside-the-park home run. The Prison Red Sox took the victory, 8-7. (Courtesy of the Moundsville Economic Development Council.)

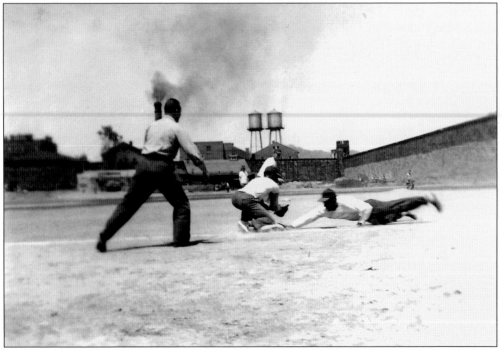

The community, as well as the inmate population, was invested in the prison's baseball team. Nevertheless, the question remains: is he safe or out? (Courtesy of the Moundsville Economic Development Council.)

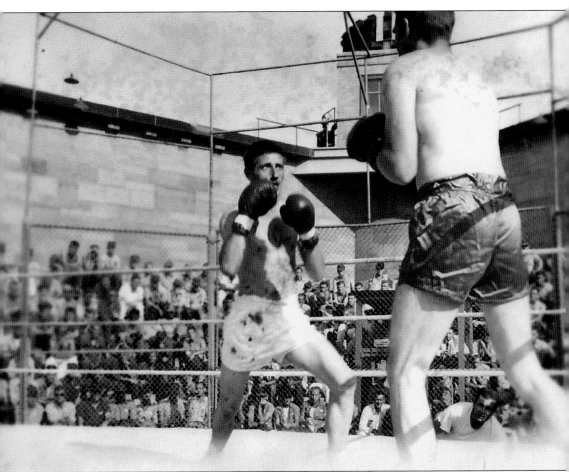

The prison's boxing team not only competed inside the penitentiary but outside as well. According to one Moundsville resident, "Some of the best prize fights . . . [and] football games in the world were held behind those walls. You could take your children there on a Sunday afternoon and mingle with the convicts—let me say inmates—and they were the deadliest killers in the United States." (Courtesy of the Moundsville Economic Development Council.)

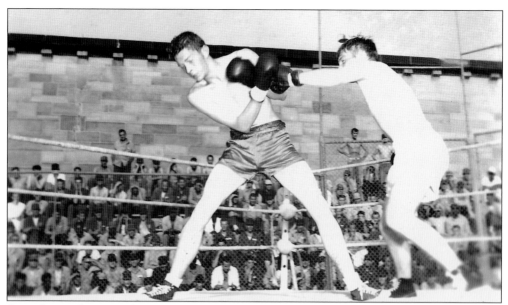

Considering the atmosphere of a state penitentiary, no one seemed to mind the violence that the inmates were subjected to in viewing the matches. (Courtesy of the Moundsville Economic Development Council.)

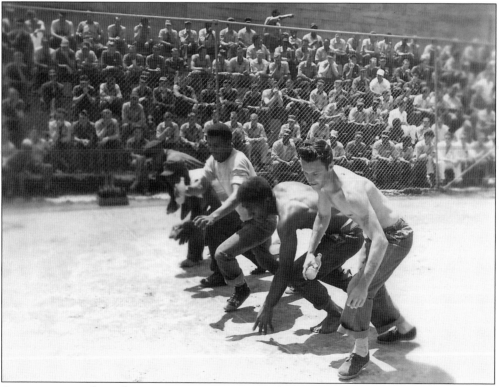

An inmate crowd watches in suspense as a group of five inmate athletes prepares for a race. Although gambling was not permitted, there was little deterrent for inmates, and many bets were placed on sporting events. (Courtesy of the Moundsville Economic Development Council.)

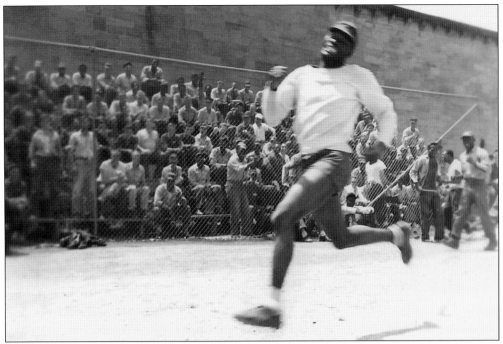

The excitement is palpable as one inmate extends considerably ahead of the others. Many inmates in the crowd are noticeably thrilled over the certain victory. Perhaps several inmates placed wise bets. (Courtesy of the Moundsville Economic Development Council.)

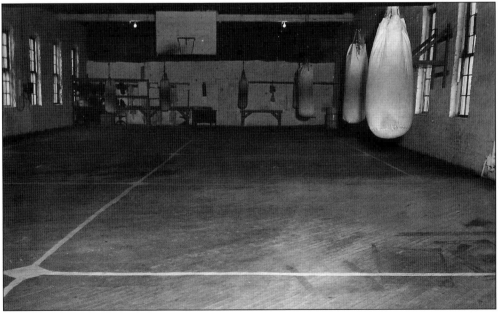

In 1958, the prison's gym was used more routinely than any other year. This was due to the Fourth of July "Sports-o-Rama," an enormous prison sporting event consisting of wrestling, boxing, basketball, and baseball. Inmate athletes trained in the gym on a regular basis; however, one particular sport dominated the gym more than any other—boxing. (Courtesy of the Moundsville Economic Development Council.)

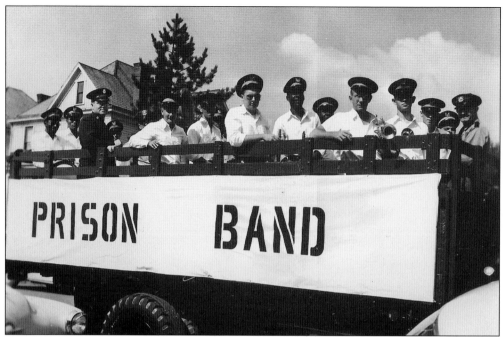

In this photograph, the prison band rides along in the Tag Day parade. The prison often used parades and other public events to increase exposure and encourage donations. (Courtesy of the Moundsville Economic Development Council.)

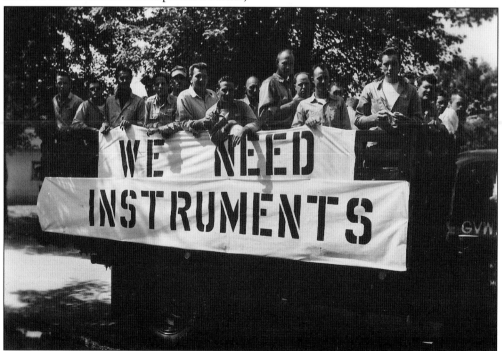

The Tag Day parade proved to be beneficial. The prison band received $500 in donations from several donors. As the band received more funding and bought more instruments, more inmates would join. (Courtesy of the Moundsville Economic Development Council.)

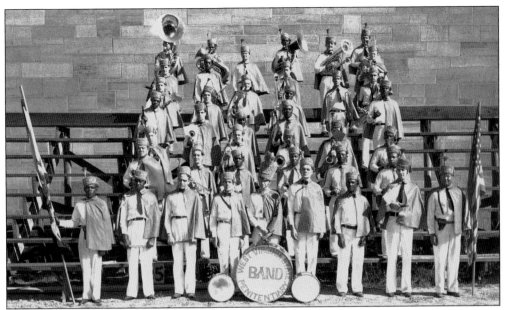

Under the direction of Harry C. Vess and the generous donations of the public, the prison band grew from 5 members to over 40 members. Equipped with their arsenal of instruments, the band would perform during the day in the yard and hold concerts at night. (Courtesy of the West Virginia State Archives.)

The prison gospel singers were immensely popular not only within the community but throughout the entire state. People paid to come see the singers perform, and the proceeds from these events went to improving the living conditions at the penitentiary. (Courtesy of the Moundsville Economic Development Council.)

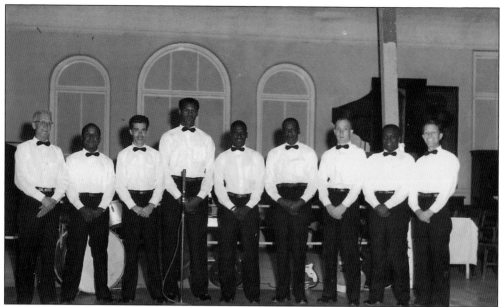

The prison gospel singers were an outstanding source of revenue for the penitentiary. The gospel singers pictured here are, from left to right, Harold Page, Oliver Gore, John Harrison, Sonny Cain, Wilbert Hampton, Theodore Johnson, Rufus Bellomy, Thaddeus Reed, and Roy Osborne. (Courtesy of the Moundsville Economic Development Council.)

Notice Notice Notice

The Prison Gospel Singers of the West Virginia Penitentiary have made a recording, which is a long-play, 33 1/3 RPM.

The recording will be available on or about January 15, 1961 and can be purchased from James M. Black & Son, Recording Studio, 1 2 0 6 Chapline Street, Wheeling, West Virginia. The price will be $ 4.00, tax included.

All profits from the sale of this record will be placed in a trust fund and used for the welfare of the inmates at the West Virginia Penitentiary, primarily the dental and the glasses program.

D. E. Adams
Warden

An advertisement from the *Penscope* provided notice of a recording made by the Prison Gospel Singers. The recording sold for $4 and was released on January 15, 1961. Profits from the sale were placed in a trust fund for the prison's dental and glasses program. (Courtesy of the Marshall University Special Collections.)

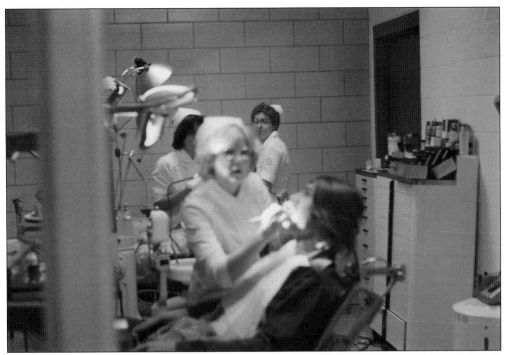

For many years, the prison's dental program only pulled teeth. By raising money during Fourth of July festivities and from the Prison Gospel Singers recording, the dental and glasses program was improved. Many of the inmates who had served long sentences had no teeth and were able to receive dentures, and others were given new eyeglasses. (Courtesy of John Massie.)

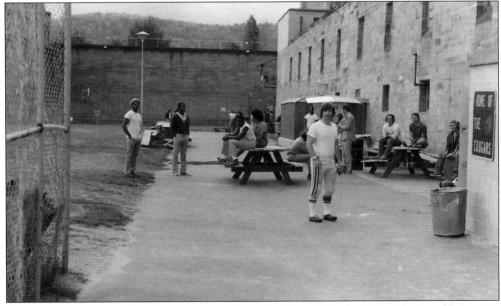

The inmates also developed a successful chess club. In 1959, the West Virginia University Chess Team traveled to Moundsville to challenge the prison's chess enthusiasts. The inmates delivered an impressive showing and defeated the West Virginia University team 3-2. (Courtesy of John Massie.)

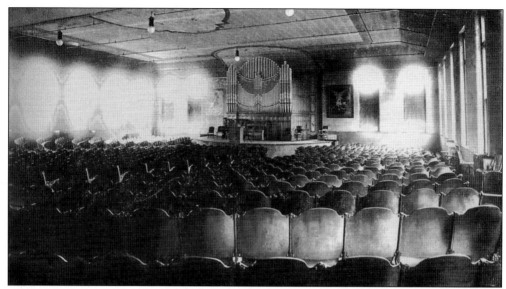

The penitentiary provided inmates the opportunity to attend religious services in the prison's chapel. Nevertheless, the atmosphere was still one of a prison and not a religious institution. By many accounts, fornication and oral sex were common activities throughout the pews. (Restoration photography courtesy of Robert Schramm.)

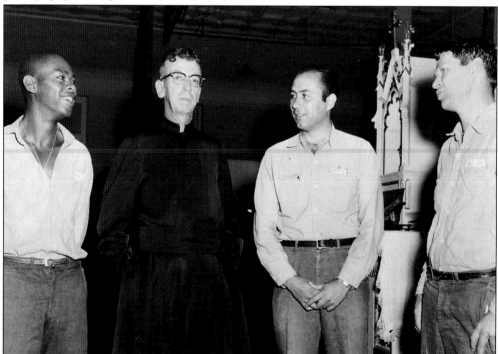

In 1962, Protestant and Catholic services were held in the prison's chapel every Sunday morning. The inmates were allowed to obtain spiritual counseling from the chaplain of their choice through a written request. The penitentiary did not provide Jewish services, since there were no Jewish inmates in the penitentiary at that time. (Courtesy of the Moundsville Economic Development Council.)

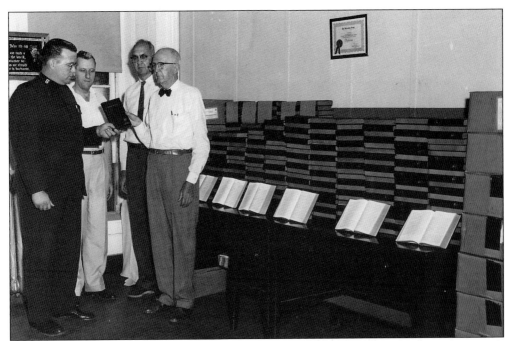

As inmate involvement in the penitentiary's worship services increased, there were not enough Bibles for all the inmates. Consequently, the Gideon Society generously donated 500 Bibles to the penitentiary. In this photograph, Lt. Morris Eads is shown receiving the donation from a representative of the Gideon Society. (Courtesy of the Moundsville Economic Development Council.)

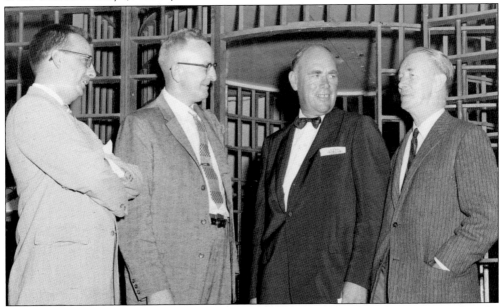

The 50 songbooks that the prison owned were insufficient for the number of inmates attending the religious services. The penitentiary began to advocate for additional songbooks by seeking assistance through local churches. The first donation the penitentiary received was 50 songbooks. Within a short period of time, the penitentiary had acquired 495 songbooks through the communities' generosity. (Courtesy of the Moundsville Economic Development Council.)

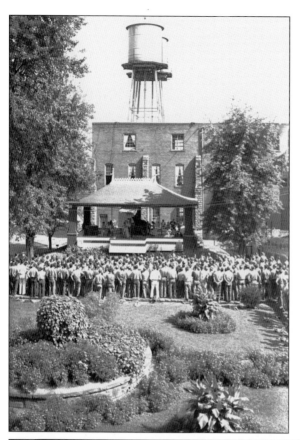

Early on Easter morning, inmates overlooked the chilly weather and attended worship services to pay respect to Jesus Christ. In addition to the worship service, inmates were given a special meal of luscious Grant County poultry, prepared to perfection. (Courtesy of the West Virginia State Archives.)

On holidays, inmates were always given exceptionally delicious meals. In this photograph, Haymer Webb prepares the hams for the prison's Christmas dinner. Webb was in charge of overseeing the slaughterhouse at Camp Fairchance. (Restoration photography courtesy of Robert Schramm.)

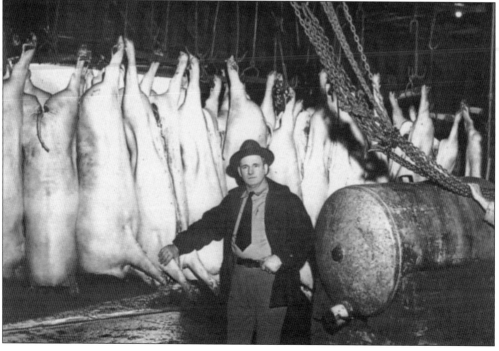

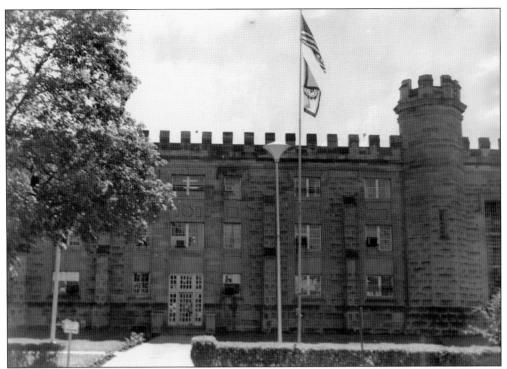

This photograph depicts the entrance used by visitors. Inmates were allowed visitors between 8:00 a.m. and 4:00 p.m. on Saturdays, Sundays, and national holidays. Each inmate was limited to one hour each visiting day and eight hours per month. (Courtesy of the Moundsville Economic Development Council.)

On August 18, 1960, the penitentiary provided inmates with another privilege, a full contact visitation room. For several men, this was their first opportunity to hold their children. Pleased with the new addition, inmate Leo Collins said, "This is the best thing that ever happened. It was swell to see my wife and to hold my children." (Courtesy of the Moundsville Economic Development Council.)

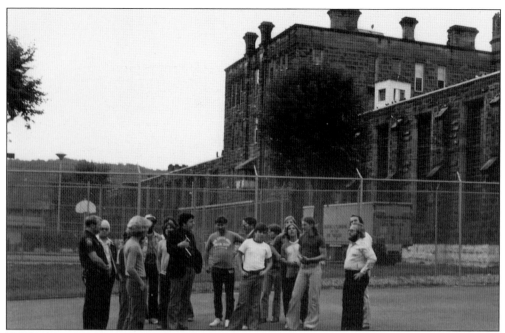

While the penitentiary was still in operation, it began offering tours to the public. The tours were immensely popular, due to the public's curiosity of the prison's inner workings. In this photograph, John Massie discusses the prison's daily operation with a group of visitors in the prison's yard. (Courtesy of John Massie.)

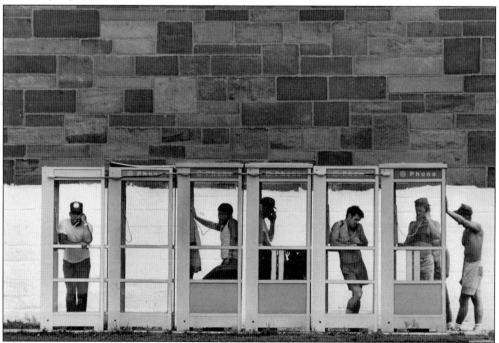

In the 1980s, phone booths were installed in the prison yard for the inmates. All outgoing calls identified the caller from the West Virginia Penitentiary. Additionally, all calls were collect, since the inmates were not allowed to have money. (Courtesy of the *Charleston Gazette*.)

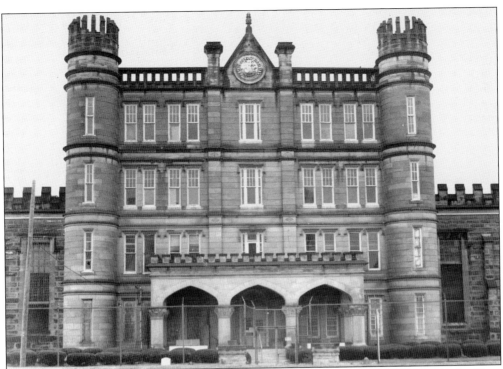

The warden and his family lived in the third and fourth floors of the administration building until 1951, when a home was build for the warden and his family on the southern portion of penitentiary grounds. (Courtesy of the Moundsville Economic Development Council.)

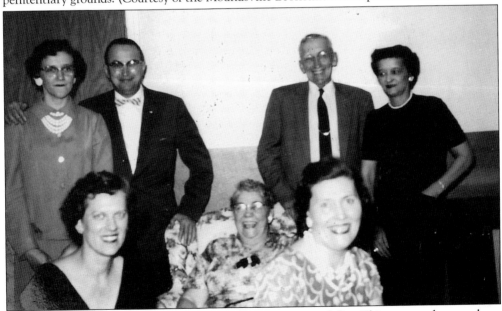

The warden's residence was an extremely challenging responsibility. This was not due to upkeep or cooking but to the tremendous amounts of entertaining that went on when guests were present. When legislators were near Moundsville, they would stop and visit. (Courtesy of the Moundsville Economic Development Council.)

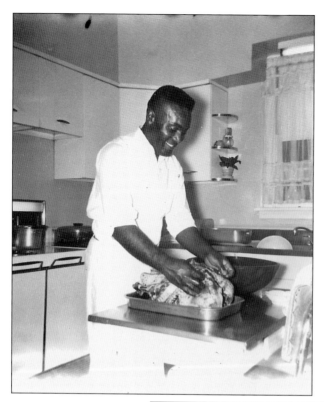

While the warden and his family were responsible for entertaining their guests, the inmates were responsible for maintaining the residence by cooking and cleaning. In this photograph, an inmate prepares a hog for dinner in the kitchen of the warden's residence. (Courtesy of the Moundsville Economic Development Council.)

The warden's residence was located on the southern penitentiary grounds. Prior to the warden's residence being built in 1951, the warden and his family lived on the third and fourth floor of the administration building. (Courtesy of the Moundsville Economic Development Council.)

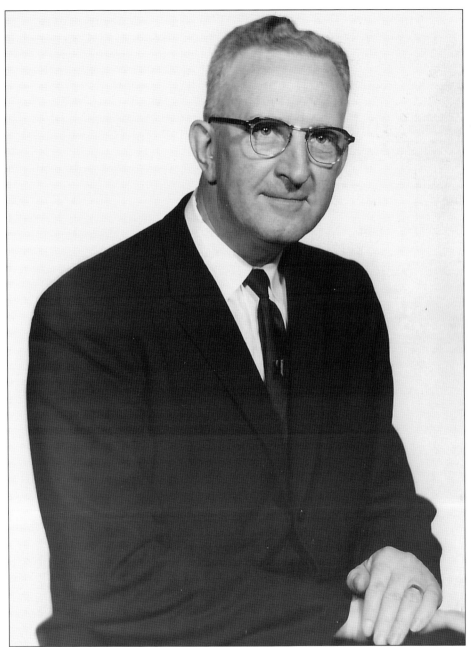

Donivon Adams was appointed as warden of the penitentiary on February 6, 1958. Upon arrival at the penitentiary, Warden Adams noted the dismal conditions of the institution and immediately notified the Federal Bureau of Prisons for assistance with the desired improvements. After touring the facility, the representative from the Bureau of Prisons said, "Don, I only know one thing that ought to be done. You ought to call in the Air Force and bomb this place off the face of the earth." Adams said, "Yes, that would solve part of it, but what do I do now?" The representative said, "Really, start any place you want to. There's so much wrong here that anything will help." Adams began making improvements to the facility almost instantly. (Courtesy of the Moundsville Economic Development Council.)

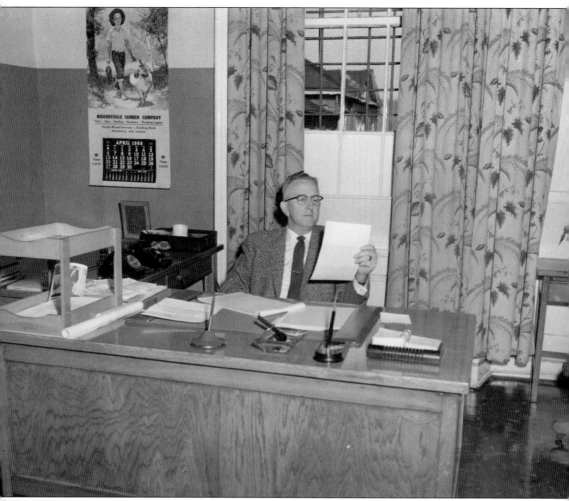

Firstly, Adams thought the most important issue to inmates was their food. Accordingly, he began to introduce a variety of well-balanced meals, such as a chicken dinner one Sunday a month and creamed chicken on another Sunday. He also tried to introduce salads, but the inmates were angry and raised so much hell that Adams had to change this immediately; the inmates were not interested in a diet but rather in meat, beans, and potatoes. Secondly, Adams began to fix the inmates' living conditions. Many of the cells had holes in the floors due to rust, so welders came into the penitentiary and fixed the cell floors. Additionally, an exterminator was hired to get rid of pests, and every cell was painted. (Courtesy of the Moundsville Economic Development Council.)

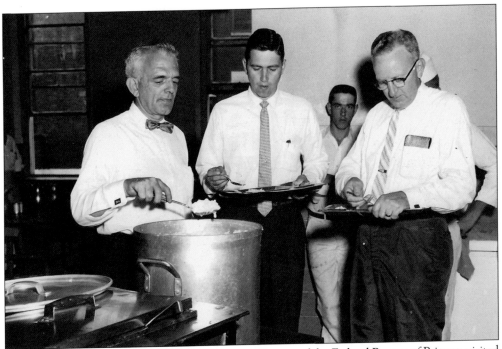

On August 21, 1958, Myrl E. Alexander, assistant director of the Federal Bureau of Prisons, visited the West Virginia Penitentiary. In this photograph, from left to right, Alexander, Deputy Warden Dodrill, and Warden Adams taste the quality of the inmates' food. (Courtesy of the Moundsville Economic Development Council.)

According to Warden Adams, the penitentiary was in terrible disarray when he was initially appointed to the position. One of the accommodation improvements Adams provided to inmates was new mattresses, which were made by inmates in the prison's mattress factory. (Courtesy of the Moundsville Economic Development Council.)

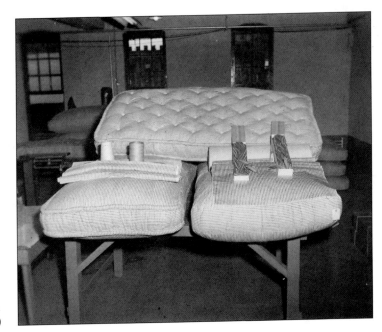

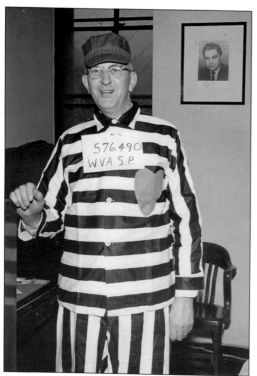

The warden's job was stressful and time consuming. Nevertheless, many of them found time to take a break from their demanding schedule and share a few laughs with the staff. In this photograph, Warden Donivon Adams assumes the role of West Virginia State Penitentiary inmate No. 576490. (Courtesy of the Moundsville Economic Development Council.)

One inmate reflects on the undemanding dress code and personal property rules, "You could have blue jeans, suits, any type of clothing and jewelry. We were allowed stereos and colored TVs, fans, and electrical appliances galore in our cells. We were allowed to have mustaches and beards and to grow hair at any length." These types of freedoms continued until the New Year's Day riot in 1986. (Courtesy of the Moundsville Economic Development Council.)

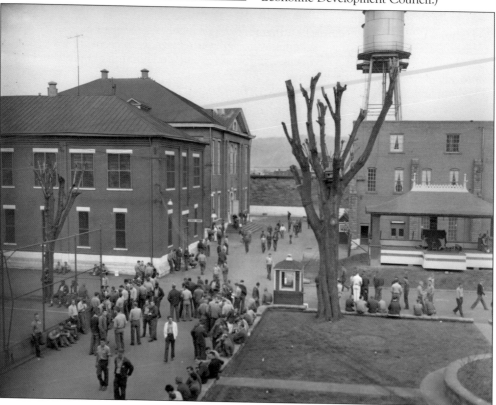

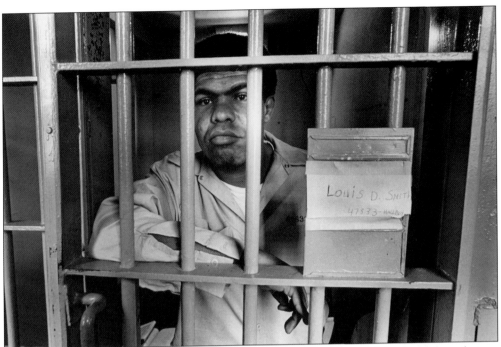

Inmates at the penitentiary followed a strict daily routine. According to the rules and regulations governing inmates, a bell rang each morning at 6:00 a.m. At this time, inmates would get up, get dressed, clean their cells, and make their beds. When the second bell rang at 6:30 a.m., inmates were required to go to their cell door and stand with one hand on the bars until they had been counted. In the evening, another bell rang. Whether inmates were in the penitentiary or on the yard, they were to go directly to their cell, pull the door shut, and wait to be counted in for the evening. (Courtesy of John Massie.)

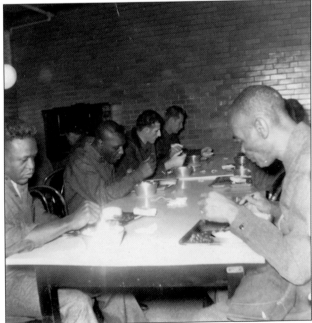

In this photograph, inmates are enjoying their dinner in the prison's cafeteria. (Courtesy of the Moundsville Economic Development Council.)

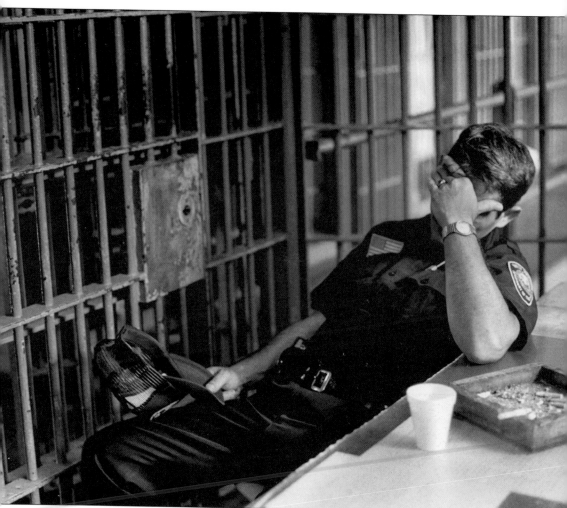

Many correctional officers feel that they, like the inmates, are serving time behind bars. In addition, the vocation of a correctional officer is extremely stressful and requires long hours with low pay. The national average turnover rate among correctional officers is approximately 17 percent; that is, 17 percent of the correctional work force had to be replaced. This is a formula for disaster. The high turnover rate also means new officers are recruited, which leads to an inexperienced staff facing experienced inmates. (Courtesy of the *Charleston Gazette*.)

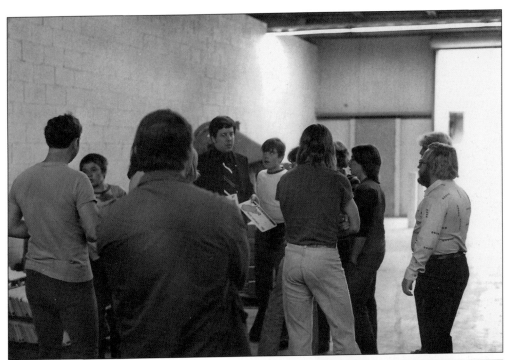

As correctional officers performed checks on inmates, occasionally they would find that one had committed suicide. According to former warden Paul Kirby, his third day on the job required him to cut down an inmate who hanged himself in the maximum-security unit. (Courtesy of the *Charleston Gazette*.)

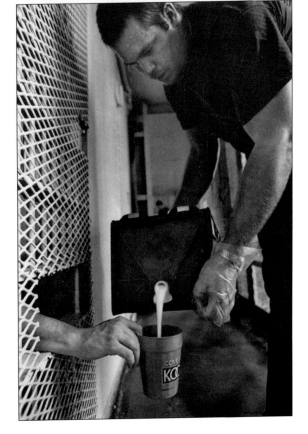

Although officers are protected by the steel bars separating them from the inmates, sometimes the barrier seems nonexistent. On many occasions, inmates would hurl urine, feces, vomit, and other hazardous materials at correctional officers. (Courtesy of the *Charleston Gazette*.)

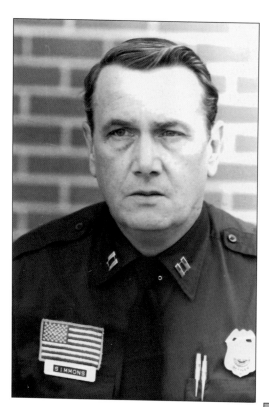

The life of a correctional officer at the West Virginia Penitentiary was unquestionably difficult. It was not uncommon for some officers to work in excess of 12 hours per day. (Courtesy of the Adkins family.)

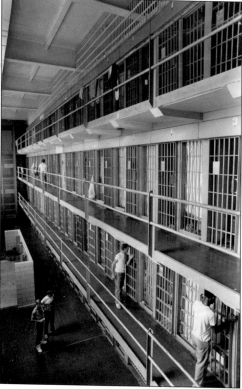

Imagine the sound of 1,800 inmates, each with his own radio turned up trying to play it louder than the man beside him. It was surely unbearable. For this reason, the penitentiary followed the trend of other institutions and installed a central radio system in 1960. This system allowed the men to listen to their desired station through a headset that was provided by the prison. (Courtesy of the *Charleston Gazette*.)

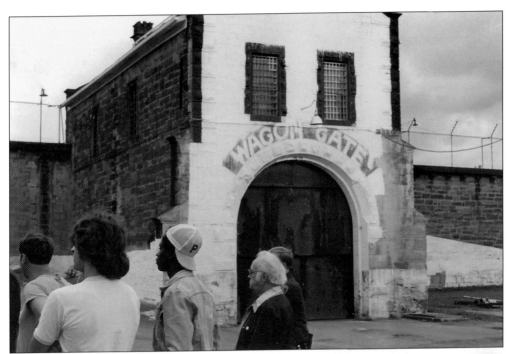

The Trail of the Dead Years, by Earl Ellicott Dudding, describes the deplorable conditions of the penitentiary as a vermin-infested "damnation." The poor conditions at the prison led Dudding to create an organization known as the Prisoners Relief Society. (Courtesy of John Massie.)

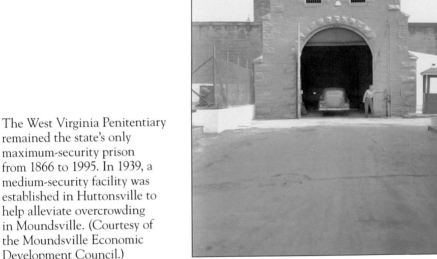

The West Virginia Penitentiary remained the state's only maximum-security prison from 1866 to 1995. In 1939, a medium-security facility was established in Huttonsville to help alleviate overcrowding in Moundsville. (Courtesy of the Moundsville Economic Development Council.)

During the early years, the legislature did not have to make any appropriations to the penitentiary. In the 1920s, the prison began to decline, due primarily to overcrowding issues. The prison's population nearly doubled, from 800 to 1,500 inmates. By the mid-1930s, there were more than 2,700 inmates confined to a prison designed with a rated capacity of 696. (Courtesy of the West Virginia State Archives.)

Two

ESCAPES, RIOTS, DEATH, AND DISTURBANCES

There is a reason why the West Virginia Penitentiary was revered as one of the bloodiest institutions in the United States. During its 129 years of operation as a penal institution, the prison unquestionably saw its share of bloodshed. Plagued by overcrowding, the penitentiary was a breeding ground for violence, at times housing in excess of 2,700 convicts in a facility designed for 696. Inmate-on-inmate violence was common, and threats, assaults, rape, and murders contributed to the penitentiary's notorious reputation. Nevertheless, inmates were not the only source of vicious hostility.

In the 1800s, during the prison's infancy, convicts were subjected to various forms of torture, which permanently scarred and killed many inmates. Following a riot in November 1979 that resulted in the murder of an off-duty state trooper, the West Virginia State Police rushed the penitentiary with gas masks and riot sticks. One inmate recalled, "The state police came in and just brutally intimidated us. They singled out for beatings inmates that sort of had it coming, if you accept that. And the other inmates, they just made it known that each minute was a potential for a beating, if you even thought of getting out of line." Regardless of the source, the environment of the West Virginia Penitentiary was a breeding ground for violence.

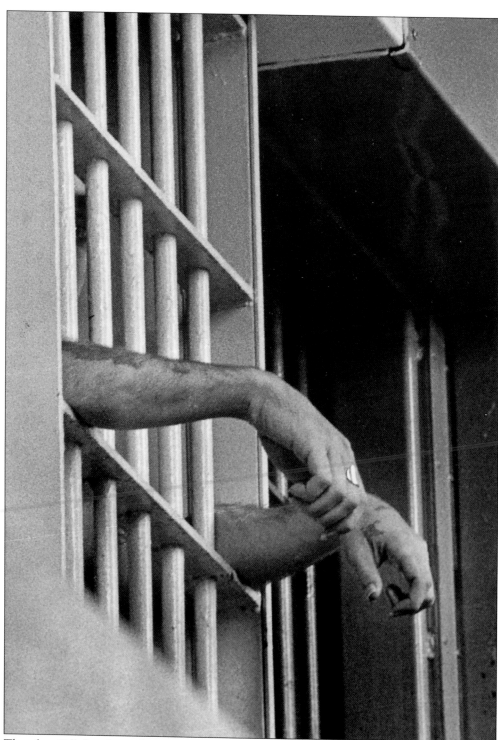

The adage "idle hands are the Devil's workshop" certainly rings true within the stone walls of the West Virginia Penitentiary. Throughout the prison's 129 years of operations, it has seen its share of escapes, riots, death, and disturbances. (Courtesy of the *Charleston Gazette*.)

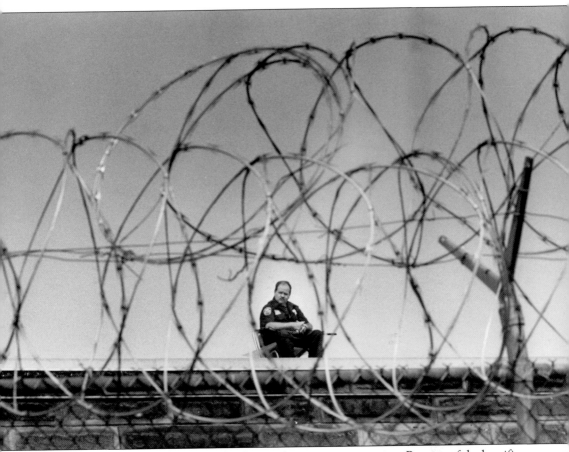

The torture, violence, corruption, and death gave the prison its reputation. Because of the horrific events that took place inside the prison walls, it was listed on the Department of Justice's "Top Ten Most Violent Correctional Facilities" list. The penitentiary has had many nicknames throughout its history; some refer to it as "Blood Alley." (Courtesy of the *Charleston Gazette*.)

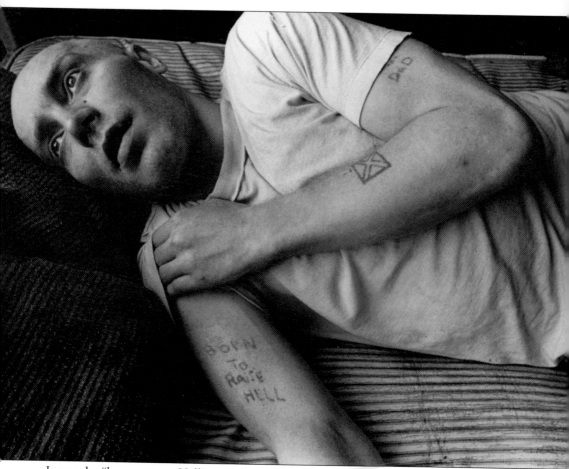

It was the "born to raise Hell" mentality of many inmates that caused the penitentiary to be such a violent place. Many of the inmates with this mentality were housed in North Hall. The inmates housed in this unit were deemed too dangerous to socialize with other inmates and were locked within the confines of their cell for 22 hours a day. The only time inmates were released was to exercise in an area surrounded by chain link fence and razor wire. (Courtesy of the *Charleston Gazette*.)

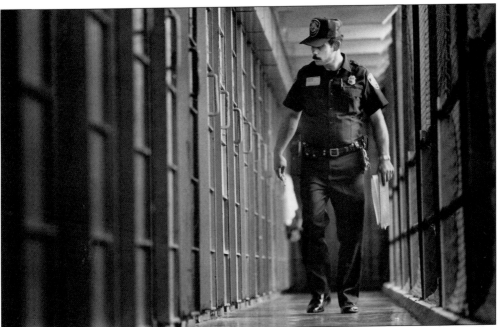

In the 1990s, North Hall was deemed the "Most Dangerous" housing unit in the United States. Although inmates were locked into their cell the majority of the day, many inmates were slaughtered in North Hall by other inmates. (Courtesy of the *Charleston Gazette*.)

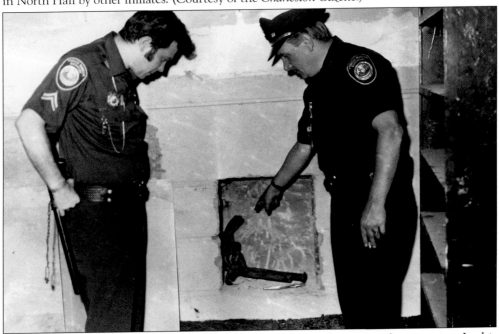

Rumors of planned escapes and riots were dealt with daily by the prison administration. In this photograph, Capt. Paul Simmons (right) reveals an area where inmates were hiding contraband. The strict and knowledgeable leadership of Captain Simmons and other ranking officers ultimately determined the orderliness of the penitentiary's daily operation. (Courtesy of the Adkins family.)

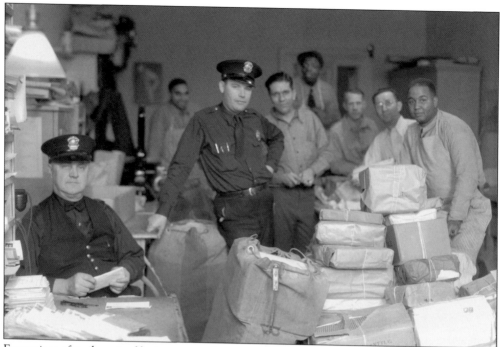

Every piece of mail received by inmates at the penitentiary was screened by prison staff. Nevertheless, inmates with influence and money could sometimes persuade officers to provide them with their mail unchecked. (Courtesy of the *Charleston Gazette*.)

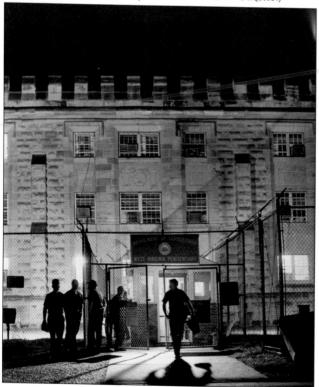

Theft, drug use, and corruption were not limited to the inmate population; many guards were involved in illegal activities within the prison. Although inmates were not allowed to have money, it remained present, and the inmates used it to their advantage. They would persuade guards to smuggle contraband into the prison. When guards were implicated in illegal activities, they were fired immediately. (Courtesy of the *Charleston Gazette*.)

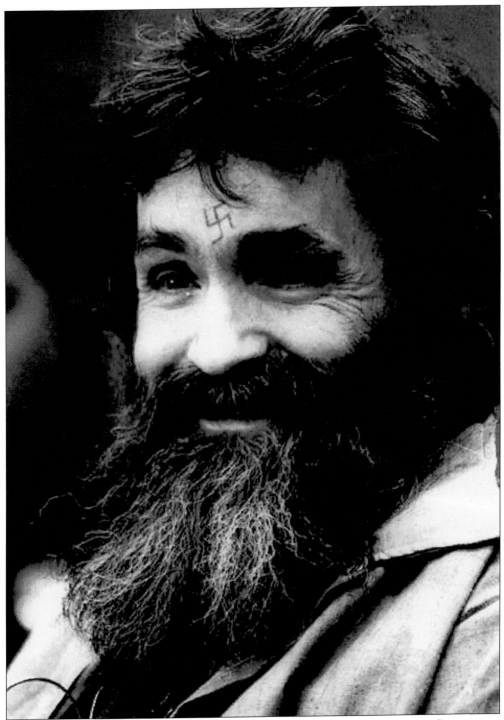

Many seem to believe that cult leader Charles Manson served time at the West Virginia Penitentiary; this is merely a widespread misconception. Nevertheless, Manson did write Warden Donald Bordenkircher a letter requesting to be transferred to the West Virginia Penitentiary. (Courtesy of the Moundsville Economic Development Council.)

Charles Manson wrote, "Dear Sir. I was razed in McMechen & Wheeling & worked at the race track under big Bill & Charlie Stoneman who put them big stones at the prison & on the road. You may know some of my ken folks God knows they been enough of us in & out of your place. I'm a beanie brother from way back. California prison people had me in the hole for 14 years. They done told a pack of lies & built up so much fear that there in fear of what they made up to start." (Courtesy of the Moundsville Economic Development Council.)

+ Calif has a transfer trip with
other states – would you accept
me at your place – I got 9
lifes + dont want out no
more chn a good worker +
I give you my word I'll
start NO trouble – I've
been in prison hallways
over 30 years + never
lied to you + never rated
that should count for
something some where –
 Thank you
 Chas Manson

1. Will you accept me – If
so I may git there on them
old CCC roads that we
built for you a while ago –

I can't seem to git no mercy from Calif –

Manson's letter continued, "& California has a transfer trip with other states. Would you accept me at your place? I got a lifes & don't want out no more. I'm a good worker & I give you my word I'll start no trouble. I've been in prison hallways over 30 years & never lied to you & never rated. That should count for something somewhere. Thank you, Charles Manson. 1. Will you accept me. If so I may get there on them old CCC roads that we built for you a while ago. I can't seem to get no mercy from Calif." Warden Donald Bordenkircher responded with, "It will be a cold day in hell." (Courtesy of the Moundsville Economic Development Council.)

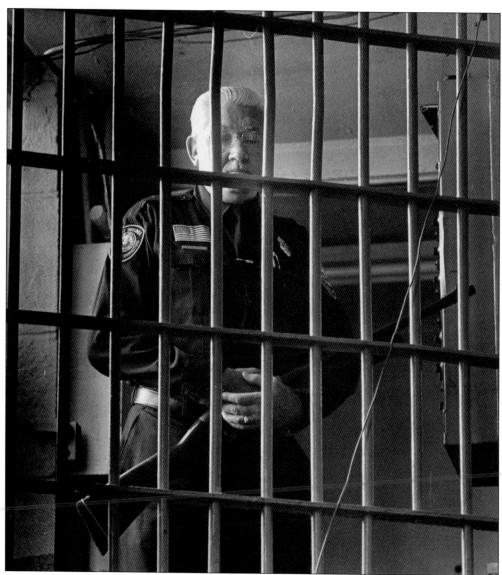

The West Virginia Penitentiary was considered a con's prison, which means that convicts preferred the West Virginia Penitentiary. One convict stated, "If you have to do time, this was the place to do it, here in Moundsville." This was due to several operational issues within the prison. Firstly, the majority of the cell locks did not lock, which allowed inmates to roam freely. Secondly, the rules were loosely enforced due to understaffing. Finally, the West Virginia Penitentiary was an exceptionally simple prison to escape from. For example, 437 inmates escaped in 1974, which was 32.5 percent of the state's entire prison population. (Courtesy of the *Charleston Gazette*.)

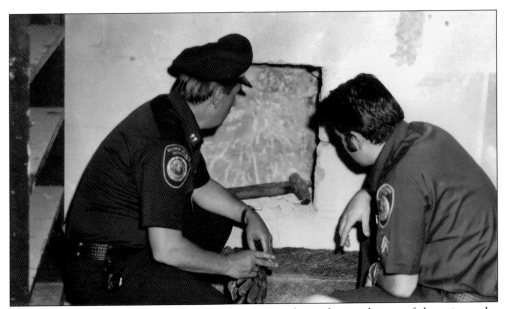

According to a consulting firm that was hired to evaluate the conditions of the prison, the penitentiary "was less secure than Reiley's Motel in [neighboring] Glen Dale." Although this may seem amusing, it was certainly not a laughing matter. The perilous conditions at the penitentiary posed a threat to inmates, staff, and society. (Courtesy of the Adkins family.)

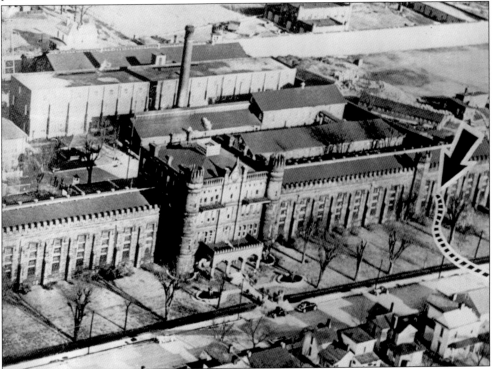

The arrow towards the right of this photograph depicts the second-floor window that 14 inmates used to escape the penitentiary on June 4, 1949. Escapes were common at the West Virginia Penitentiary. (Courtesy of the Moundsville Economic Development Council.)

According to former Warden Donald Bordenkircher, "Dental floss in a penitentiary is not your friend. The concept of using dental floss and an abrasive powder to cut through steel bars, even to reasonable men, is unbelievable." Nevertheless, this is exactly what many inmates were doing. This technique allowed them to cut sheet steel from their beds to form shanks and escape by cutting through the steel bars of their cell. (Courtesy of the Moundsville Economic Development Council.)

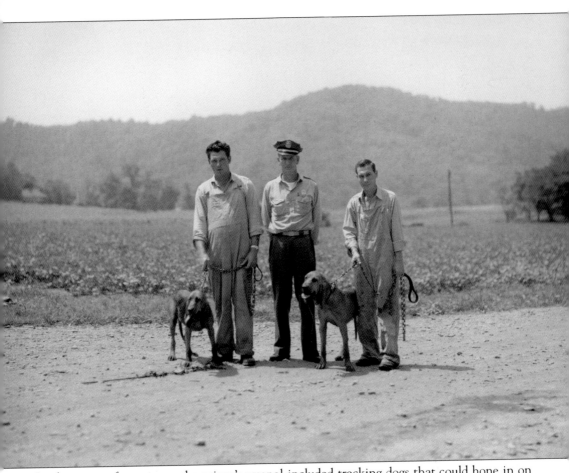

In the event of an escape, the prison's arsenal included tracking dogs that could hone in on the scent of the escapee. The dogs proved to be a wise investment, because the penitentiary experienced a tremendous amount of escapes throughout its 129 years as an institution. (Courtesy of the West Virginia State Archives.)

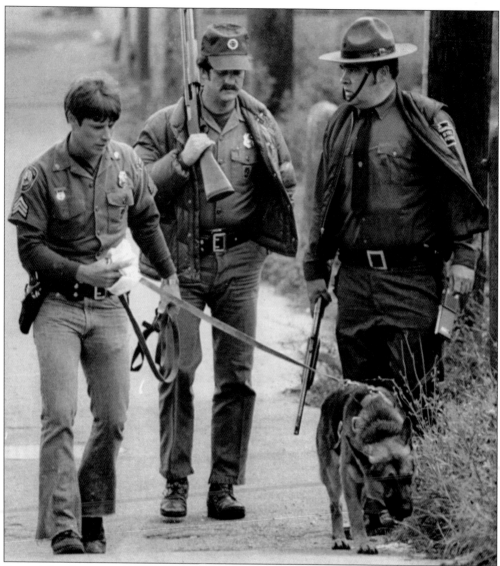

Essentially, the prison can be divided into two phases. Prior to November 1979, the rules at the penitentiary were loosely enforced. Inmates were allowed to roam freely and had seemingly limitless personal property and freedom of dress. However, in November 1979, a prison escape and the murder of an off-duty state trooper abruptly ended this phase and transitioned the prison into a new era. On November 21, 1979, one hundred West Virginia state troopers entered the prison. Every inmate was locked into his cell, sheets covering the inmates' cell doors were torn down, non-essential property was taken out of cells, and inmates lost visiting privileges. During the 10-day takeover by the state police, many inmates claim that police ruthlessly beat inmates with riot sticks, denied them medical treatment, and mistreated them. (Courtesy of the *Charleston Gazette*.)

Following the escape of 15 inmates and the murder of a state trooper, all inmates were punished and lost visiting privileges. Many of the inmates' family members protested the disciplinary action imposed upon the prison population that was not involved with the escape, since it prohibited them from visiting their loved ones. (Courtesy of the *Charleston Gazette*.)

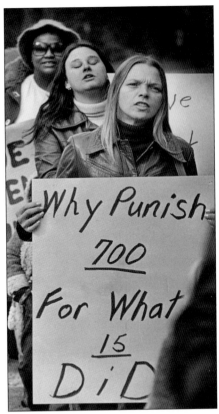

Following the escape in November 1979, Gov. John Rockefeller appointed Donald Bordenkircher as warden to tighten the penitentiary's security. Bordenkircher said he was going to, "tighten the place up so much, it squeaks." For the first time in the history of the prison, there were no escapes within a year. Moreover, no escapes occurred in 1980, 1981, or 1982. Bordenkircher stood by his promise and is now revered as one of the penitentiary's most respected wardens. (Courtesy of the Moundsville Economic Development Council.)

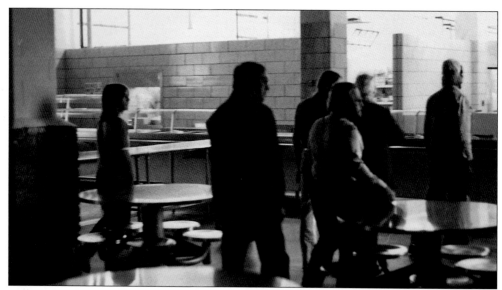

In order to evaluate an officer's performance, Warden Donald Bordenkircher would remove an inmate from his cell, take him to his office, and time how long it took for the inmate's disappearance to be reported. (Courtesy of John Massie.)

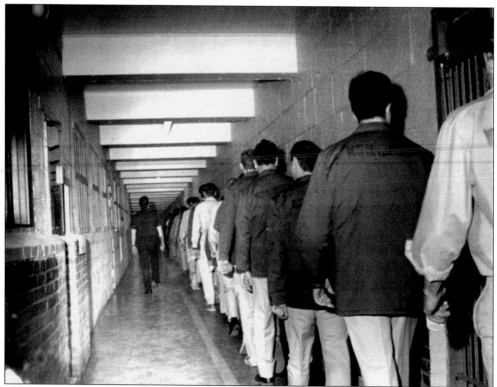

Following a massive escape on November 17, 1979, the penitentiary began to implement strict security measures. Prisoners were required to walk single file on one side of a newly painted yellow line while the correctional officers walk on the opposite side. Additionally, the inmates were to be accompanied by guards at all times. (Courtesy of the *Charleston Gazette*.)

Perhaps one of West Virginia's most infamous criminals is Ron Williams. He led a massive prison escape on November 7, 1979. During the escape, 23-year-old off-duty state trooper Philip Kesner was killed. This event made the sixth escape for Williams from jails and prisons. He was captured following a shoot-out with federal agents. He was transferred to Mount Olive Correctional Complex during the closing of the West Virginia Penitentiary. (Courtesy of the Moundsville Economic Development Council.)

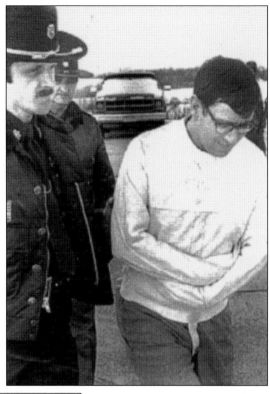

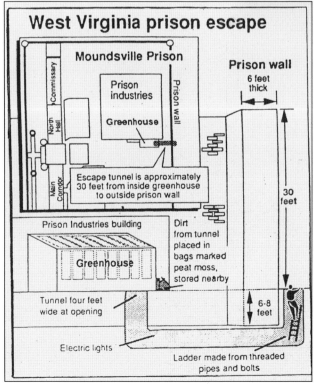

West Virginia prison escape

Moundsville Prison

Commissary

North Hall

Main Corridor

Prison industries

Greenhouse

Prison wall

Prison wall
6 feet thick

30 feet

Escape tunnel is approximately 30 feet from inside greenhouse to outside prison wall

Prison Industries building

Greenhouse

Dirt from tunnel placed in bags marked peat moss, stored nearby

Tunnel four feet wide at opening

6-8 feet

Electric lights

Ladder made from threaded pipes and bolts

Perhaps the most elaborate and shocking escapes the West Virginia Penitentiary had even seen occurred in February 1989. Inmates Tommie Lee Mollohan, David Williams, and Frederick Hamilton, while working in the prison's greenhouse, began to supply the entire prison with beautiful flowers. Many of the guards even took flowers home to their families. As the three began supplying endless amounts of pots, no one questioned where the soil was coming from. It was coming from an elaborate tunnel system the three used to escape. (Courtesy of the Moundsville Economic Development Council.)

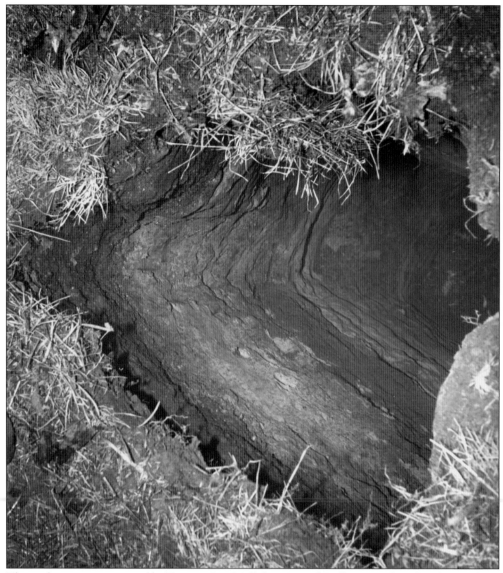

This is the escape route used by Tommie Lee Mollohan, David Williams, and Frederick Hamilton, whose elaborate escape plan went unseen. The most dumbfounding of all is that Mollohan and Williams had worked together and escaped the prison earlier in April 1988. Ultimately, the escape led to the resignations of Corrections Commissioner Ron Gregory and Warden Carl Legursky. (Courtesy of the *Charleston Gazette*.)

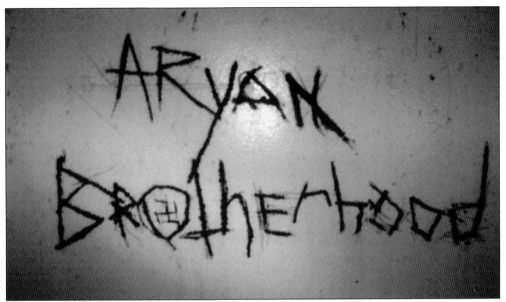

The development of cliques is frequent in social environments, and prison life is no exception. The West Virginia Penitentiary had its share of prison gangs and inmate groups. Perhaps the most notorious and dangerous was the Aryan Brotherhood. Many homicides were directly related to gang affiliation. Some inmates triumphantly displayed their gang affiliation in their cells. (Courtesy of the author.)

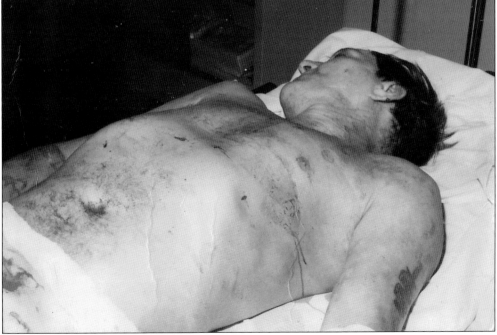

On January 27, 1985, while serving life behind bars, inmate No. 48144, Roland Vance, was sadistically stabbed to death by James Adkins and David Morgan. Living a life behind bars has its risks, and Vance is but one example of the many inmates who succumbed to these dangers. (Courtesy of the Moundsville Economic Development Council.)

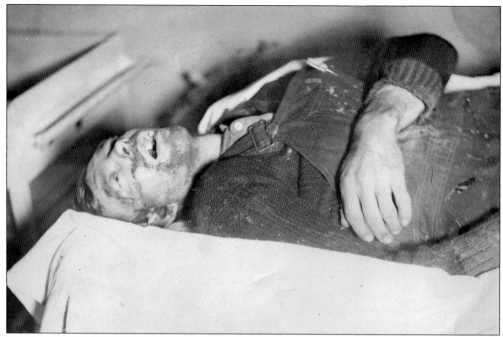

Nearly 1,000 individuals perished within the confinement of the prison's cold stone walls. Of course, not all of the departed were savagely murdered—many died of natural causes. In the 1920s and 1930s, an outbreak of tuberculosis claimed many lives. The inmates were noticeably fearful of catching the ailment. (Courtesy of the Moundsville Economic Development Council.)

Considering the violent history of the prison, it may come as a surprise that, in 1963, a report notes that approximately two crimes accounted for more than 60 percent of the prison's population. The punishment for these crimes was a relatively short prison sentence, between 1 and 10 years. The majority of the inmates were only locked in their cells during the night unless the prison was on lock-down due to a major disturbance. (Courtesy of the *Charleston Gazette*.)

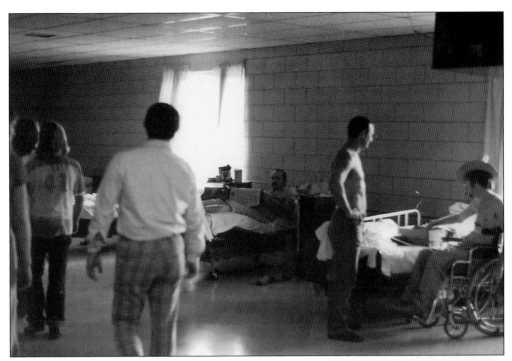

In the 1920s and 1930s, tuberculosis was an epidemic within the penitentiary. The penitentiary even had a separate medical ward dedicated to those inmates diagnosed with tuberculosis. During this period, tuberculosis caused the death of more inmates than any other cause. (Courtesy of John Massie.)

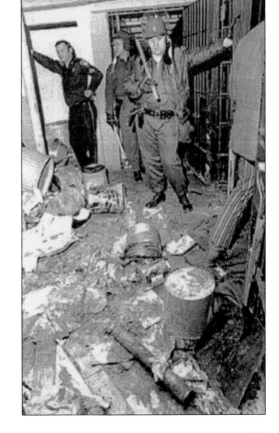

Following the 24-hour prison riot on March 20, 1973, West Virginia State Police and correctional officers assessed the damage caused at the hands of inmates. During the riot, five guards were held hostage and an inmate was killed. (Courtesy of the Moundsville Economic Development Council.)

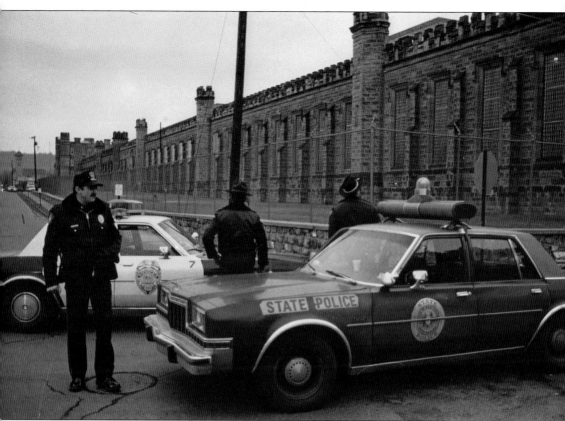

Perhaps the most famous riot at the West Virginia Penitentiary occurred on New Year's Day, 1986, and is commonly known as the "Routine" Riot. Routine "illnesses" seemed to happen every year on New Year's Day, and this year was no different. Some 16 officers called in sick during the 3:00 p.m. to 10:00 p.m. shift, resulting in only 31 men working; this number was below the critical level and procedure called for a lockdown of the penitentiary; however, this was not done. During dinner, 20 inmates armed with knives stormed the mess hall. Several officers were taken hostage. An Avenger leader yelled, "Leave the fucking food alone—we've taken the penitentiary—let's go." (Courtesy of the *Charleston Gazette*.)

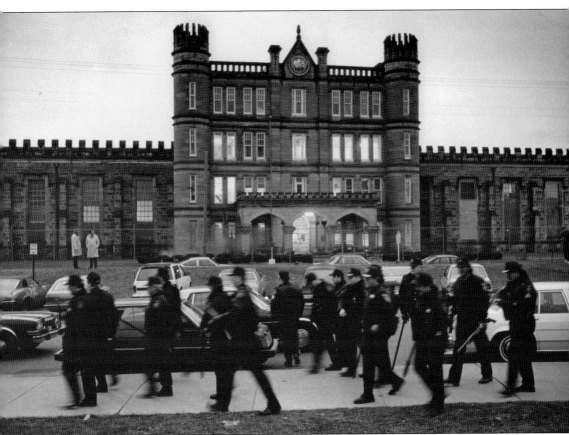

The inmates handled the riot in a democratic, business-like manner. With the law library serving as a command post, inmates voted that the Avengers' president, Danny Lehman, was best suited to lead negotiations. Lehman requested the assistance of Alvin Gregory to aid him in the negotiations. On January 2, the inmates' primary demand was to meet with the governor, because they thought the governor would be the one person who would listen and take action. After everything began to settle back into place, the inmates met the governor. The reason for the riot was simple: the inmates wanted better living conditions. During the 42-hour riot, three inmates were killed. First, Kent Slie was murdered due to an existing vendetta with another inmate. Second, inmate and informant Robert Dean was severely beaten and dropped from a third tier in the P&R housing unit with a telephone cord around his neck. The cord broke, and Dean died from impact a few hours later. Finally, Jeff Atkinson was killed when another inmate shoved a screwdriver through his throat for murdering a pregnant woman. (Courtesy of the *Charleston Gazette*.)

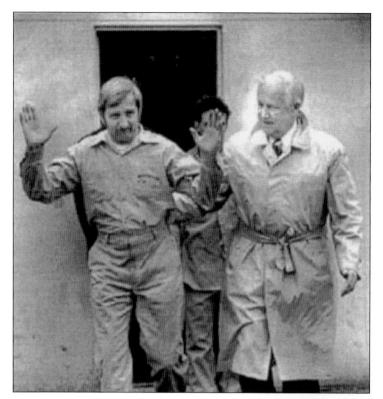

After a 42-hour standoff during the New Year's Day riot, Gov. Arch Moore leads an officer to safety after he was held captive by the inmates. (Courtesy of the Moundsville Economic Development Council.)

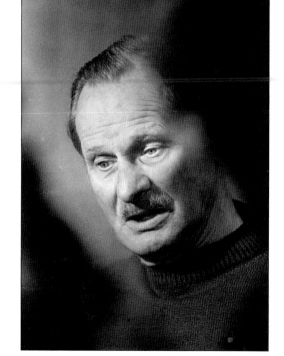

Correctional officer Ray Gaughenbaugh was one of the correctional officers who were taken hostage in the New Year's Day riot. According to Gaughenbaugh, one of the inmates said to another inmate, "If you harm this guard we're going to cut you." (Courtesy of the *Charleston Gazette*.)

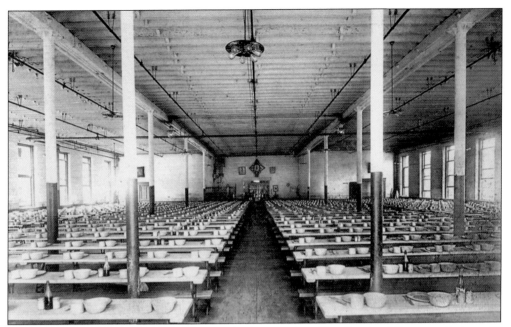

The last major riot at the penitentiary took place in the old cafeteria. After negotiations, 16 hostages were released. In return, the inmates would receive a new cafeteria with heat and air. The new cafeteria would be the only room in the penitentiary to have these amenities. (Restoration photography courtesy of Robert Schramm.)

West Virginia Penitentiary

ADMIT BEARER TO

EXECUTION CHAMBER

Orel J. Skeen

WARDEN

GOOD FOR THIS DATE ONLY

Sept. 23, 1948

Execution tickets were a hot commodity. It may be surprising, but people enjoyed taking part in an execution. Often tickets were sold or traded. This execution ticket gained the bearer admittance to the execution of Mathew O. Perison on September 23, 1948. Perison was convicted of murder in Logan County. (Courtesy of the West Virginia State Archives.)

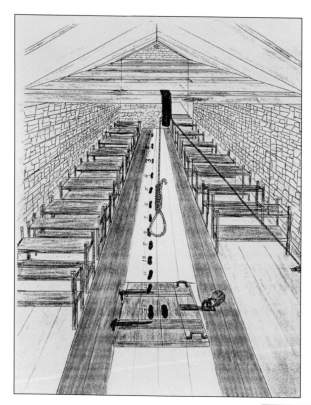

This is an inmate's drawing of the North Wagon Gate. This area was not only used for executions by hanging, but it was also used as a housing unit during the prison's infancy. Shep Caldwell, a 25-year-old African American, was convicted of murdering a woman and was the first to be hanged at the penitentiary. According to the newspapers, Caldwell dropped 6 feet when the trap door was released and died of a broken neck. Nevertheless, his heart continued to beat for 10 minutes after the trap door was released. (Courtesy of the West Virginia State Archives.)

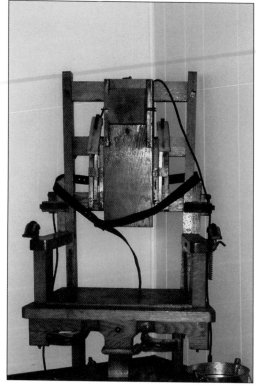

The electric chair used at the penitentiary was nicknamed "Old Sparky." It was built in 1950 by inmate Paul Glenn, who later had to be transferred to another prison to prevent other inmates from killing him. The chair was used to execute nine inmates from 1951 to 1959. West Virginia abolished the death penalty in 1965. (Courtesy of the author.)

When an inmate is executed by electric chair, it is a gruesome and grotesque sight. According to U.S. Supreme Court justice William Brennan, "the prisoner's eyeballs sometimes pop out and rest on [his] cheeks. The prisoner often defecates, urinates, and vomits blood and drool. The body turns bright red as its temperature rises, and the prisoner's flesh swells and his skin stretches to the point of breaking. Sometimes the prisoner catches fire. . . . Witnesses hear a loud and sustained sound like bacon frying, and the sickly sweet smell of burning flesh permeates the chamber." (Courtesy of the West Virginia State Archives.)

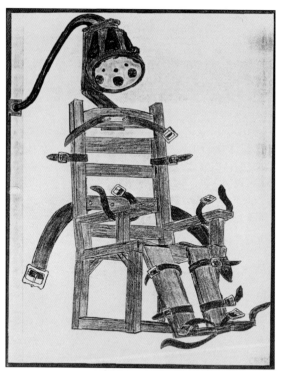

In many instances after an electrocution, the deceased's body is hot enough to cause blisters if touched, and in most cases, the brain is completely cooked. (Courtesy of the West Virginia State Archives.)

Elmer David Brunner was the last man to be executed in West Virginia on April 3, 1959. He was convicted of killing a Huntington woman who had startled him as he was robbing her home. Nonetheless, he maintained his innocence and embraced religion in his final days. (Courtesy of the *Charleston Gazette*.)

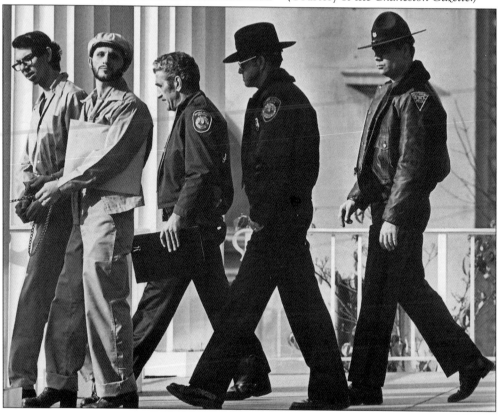

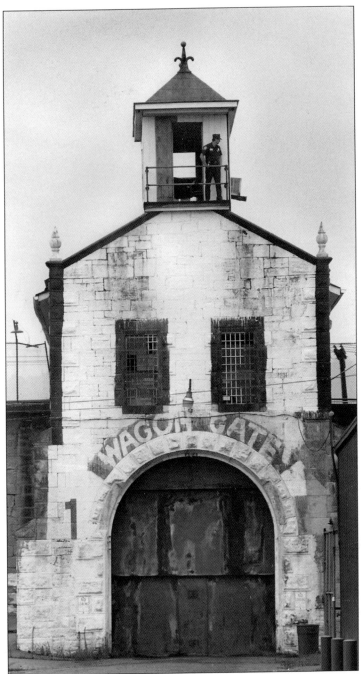

Not all executions at the penitentiary were problem free. A few hangings at the penitentiary went awry. On June 19, 1931, the hanging of inmate Frank Hyer went wrong when he was decapitated when the trap doors were opened. On March 21, 1938, inmate Orville Adams was condemned to die by hanging. While awaiting his fate, the trap doors opened prematurely and Adams plunged headfirst onto the concrete below. Adams was severely injured and had to be carried on a stretcher. This time, the noose was placed around his neck, and he was hanged. (Courtesy of the *Charleston Gazette*.)

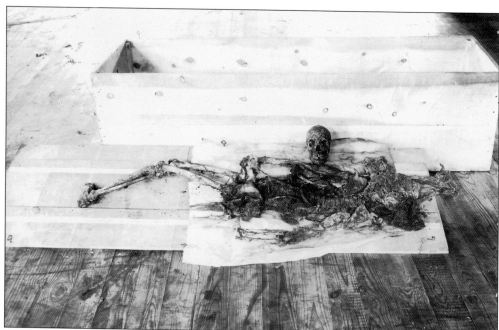

A total of 104 executions took place at the penitentiary. Hangings were used at the penitentiary until 1949, when the legislature found electrocution more humane. Executions took place in the death house until 1965, when West Virginia abolished the death penalty. (Courtesy of the Moundsville Economic Development Council.)

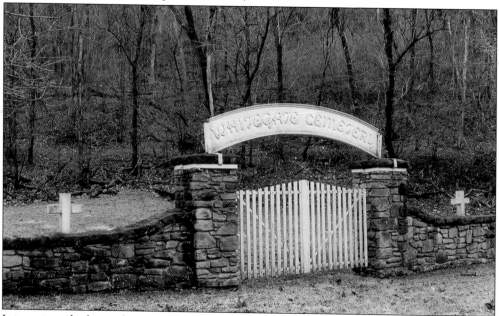

It is against the law to bury an inmate within Moundsville's city limits. Accordingly, deceased inmates whose bodies were not claimed by family were buried on Tom's Run, which is approximately 4 miles from the prison. The cemetery was named after the white gate that was put up in the 1950s—hence the name Whitegate Cemetery. (Courtesy of the Moundsville Economic Development Council.)

In the event of an inmate's death, a floral fund was collected, and each inmate contributed 1¢ to provide flowers to embellish the deceased's final resting place. (Courtesy of the Moundsville Economic Development Council.)

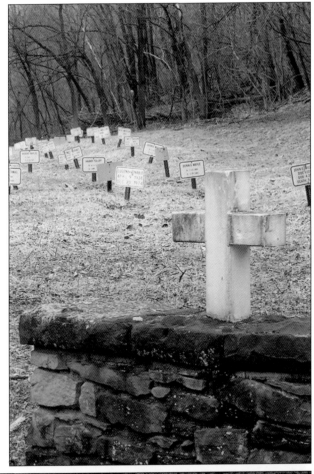

The actual number of inmates who perished within the penitentiary is unknown. According to prison records, the number of documented deaths is 998. However, this number is not correct. The penitentiary's poor documentation is to blame, and the information will never be known. (Courtesy of the Moundsville Economic Development Council.)

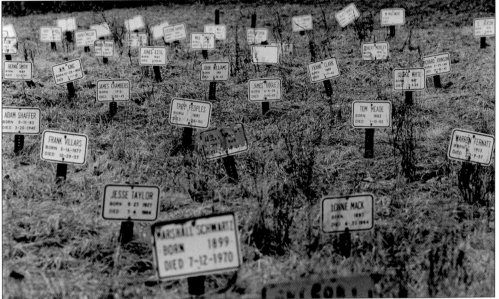

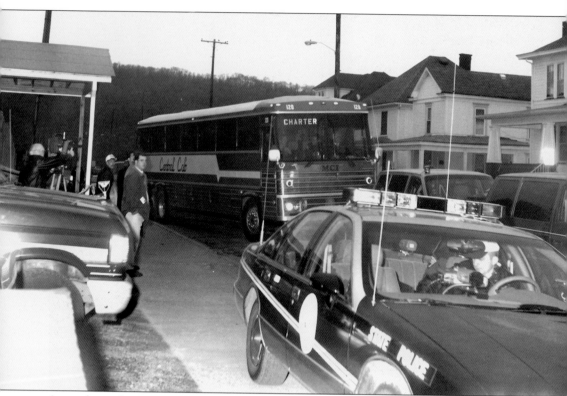

As conditions began to worsen, complaints became an epidemic. Thirty-six cases were combined into *Crain v. Bordenkircher* in February 1982, and they came to trial in Judge Arthur A. Recht's court. It was ruled that the West Virginia Penitentiary violated the Eighth Amendment, which prohibits cruel and unusual punishment. Furthermore, the penitentiary violated the West Virginia Supreme Court ruling in *Cooper v. Gwinn* that inmates have a right to rehabilitation. In 1986, the West Virginia Supreme Court ruled that the penitentiary must be closed by July 1992. (Courtesy of the Moundsville Economic Development Council.)

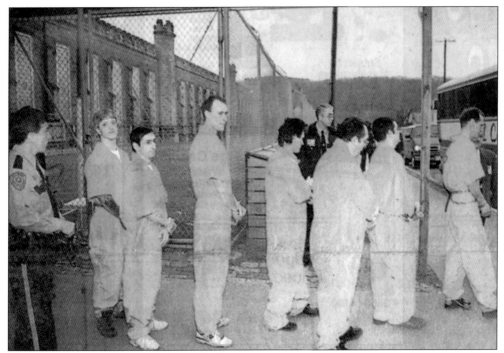

On March 27, 1995, the last group of inmates was transferred from the West Virginia Penitentiary to the Mount Olive Correctional Complex in Fayette County. This day marked the closing of the state's second oldest public building as a correctional facility. Nevertheless, the prison's legacy was just beginning. (Courtesy of the Moundsville Economic Development Council.)

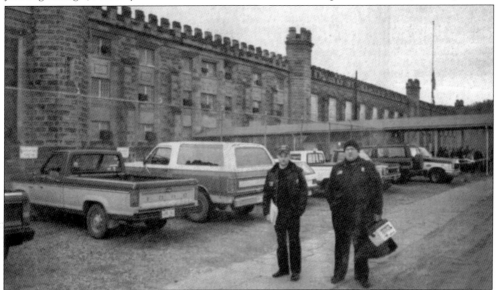

As correctional officers David Young (left) and Todd Wagner (right) leave the penitentiary for the last time, the fate of the prison is uncertain. Ideas of transforming the penitentiary into a mall were mentioned but ultimately abandoned. Eventually, the prison was adopted by the Moundsville Economic Development Council, and tours were opened to the public. (Courtesy of the Moundsville Economic Development Council.)

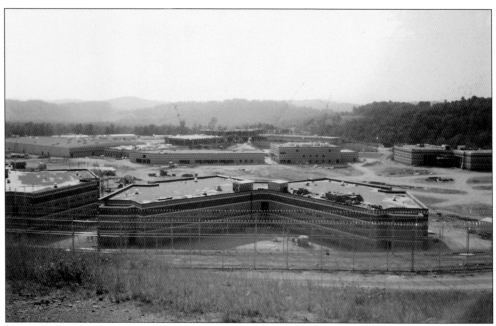

Once the West Virginia Penitentiary closed, the Mount Olive Correctional Complex took over as the state's maximum-security prison. The facility was dedicated on December 12, 1994, and received its first group of inmates on February 14, 1995. (Courtesy of the Moundsville Economic Development Council.)

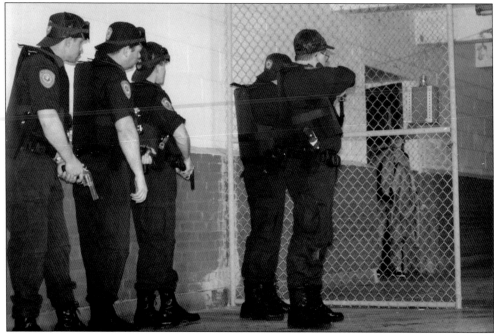

The West Virginia Penitentiary is the location for a mock riot for law enforcement and correctional officers. The mock prison riot is the only chance for officers to receive hands-on training for a prison riot. The participants can use the classroom training and incorporate modern technology in real-world conditions. (Courtesy of the Moundsville Economic Development Council.)

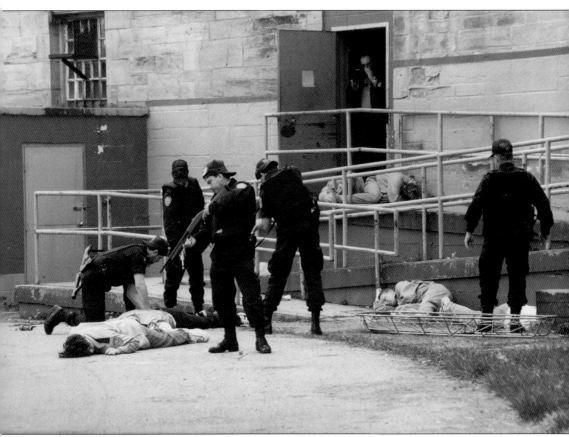

Lt. Michael Rosenburg of the Suffolk County Sheriff's Office holds the mock riot in high regard. He said, "I have attended many conferences in my 25-year career, but none came close to the training and experience held at the West Virginia Mock Prison Riot." (Courtesy of the Moundsville Economic Development Council.)

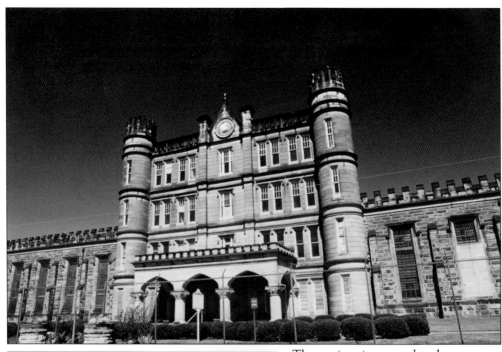

The penitentiary stretches down Moundsville's Jefferson Avenue and sits patiently, waiting for its next group of convicts to riot or escape. (Courtesy of the Moundsville Economic Development Council.)

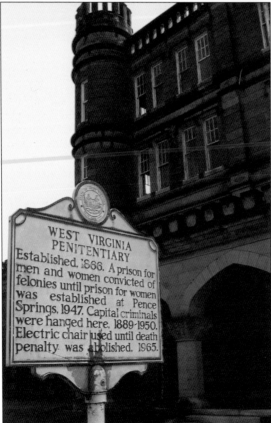

On September 19, 1996, the West Virginia Penitentiary was listed on the National Register of Historic Places. Today, the penitentiary serves West Virginia's northern panhandle as a popular tourist destination. The penitentiary not only provides an insightful educational tour but also provides for those seeking paranormal activity. (Courtesy of the Moundsville Economic Development Council.)

Three

PENITENTIARY LEGENDS

February 20, 2009, was a cold, eerie night with overcast skies in Moundsville, West Virginia, home of the infamous West Virginia Penitentiary. As the group drove down Jefferson Avenue for the first time, they were uneasy, even scared. Soon, like many of the inmates before them, they would be locked within the stone walls of the enormous prison. Skeptical of the paranormal, they found it unusual that part of them was screaming to run away, while the other half was begging to walk inside.

They were greeted at the prison gate at 11:30 p.m. by Internal Coordinator Tom Stiles, whom they followed into the prison. Once inside, they were pleased to have the opportunity to warm up in the only heated area of the penitentiary. This space was once used as a visitation area for inmates and their guests. The warmth quickly left them as they were greeted by a rectangular glass door, outlined in red paint, and the sound of a loud buzzer. The door began to open, and they were met once again by the brisk, 19-degree air of the unheated prison and total darkness. They immediately turned on their flashlights and fumbled for their cameras. They were scared and cold but nevertheless excited for the night ahead.

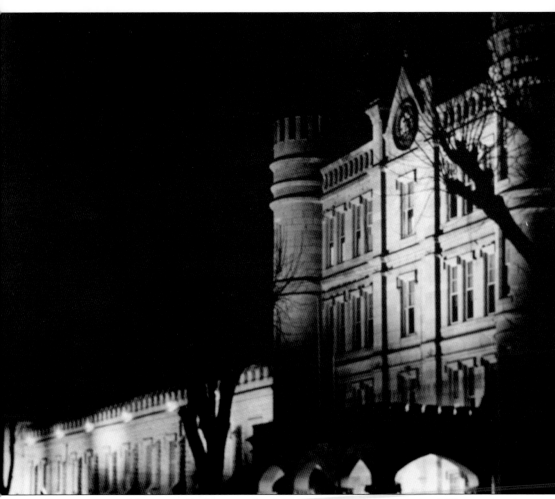

Do unseen astral beings stalk the grounds of the West Virginia Penitentiary? The penitentiary is nationally recognized for its infamous history and countless tales of paranormal phenomena. The prison has been featured on several television shows, such as ABC's *Scariest Places on Earth*, the Travel Channel's *Ghost Adventures*, and MTV's *FEAR*. By many accounts, the penitentiary is plagued by the spirits of those who once called the place home. Nonetheless, these views do not stand unopposed. Many skeptics maintain that the beliefs of paranormal activity are fanciful fabrications of the mind. The penitentiary offers daily tours as well as overnight ghost hunts, so visitors can make the determination for themselves. (Courtesy of the Moundsville Economic Development Council.)

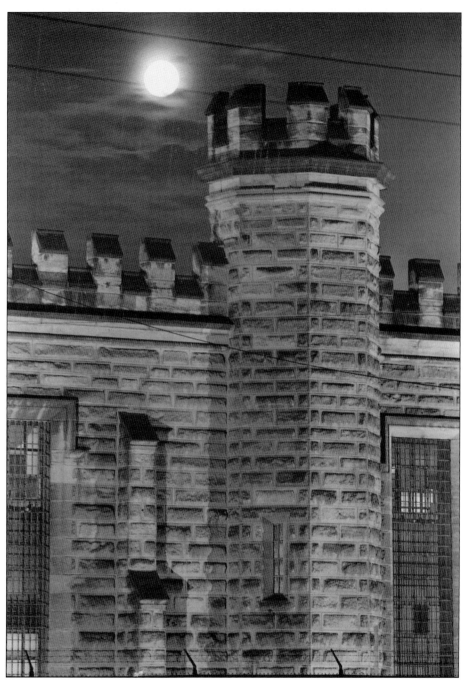

Tales of paranormal happenings began well before the closing of the penitentiary in 1995. During the prison's operation, many inmates and guards claim to have heard voices coming from vacant rooms and witnessed a shadow walking within the prison walls. In an episode of the Travel Channel's *Ghost Adventures*, former correctional officer Ed Littell recalls his experiences: "Midnight shift you're sitting up in one of the towers, you see shadows, you hear noises. You send the yard officer around to check it out, he doesn't see anything, he thinks you're crazy." (Courtesy of the *Charleston Gazette*.)

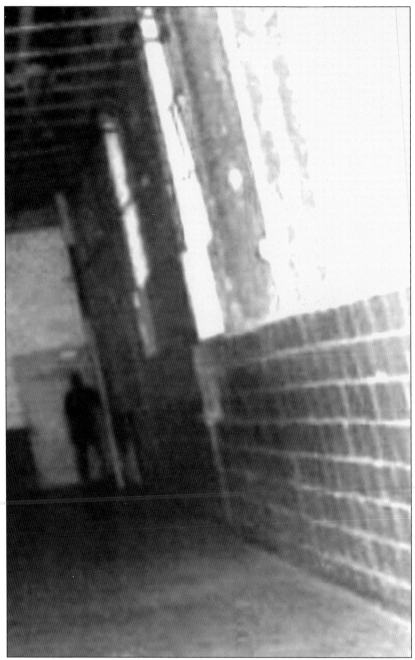

Perhaps one of the most popular legends about the penitentiary is "Shadow Man." This image was captured in May 2004 by Polly Gear. The photograph depicts a black mass that appears to be in the shape of a man. According to Gear, "I saw this shadow walking toward me, I shined a light on it, it jumped and I walked backwards and took a picture." However, the Atlantic Paranormal Society (TAPS) recreated the photograph and ultimately ruled that since the picture could be recreated it could not be recognized as proof of paranormal activity. Nevertheless, "Shadow Man" has been seen and photographed by many others. (Courtesy of the Moundsville Economic Development Council.)

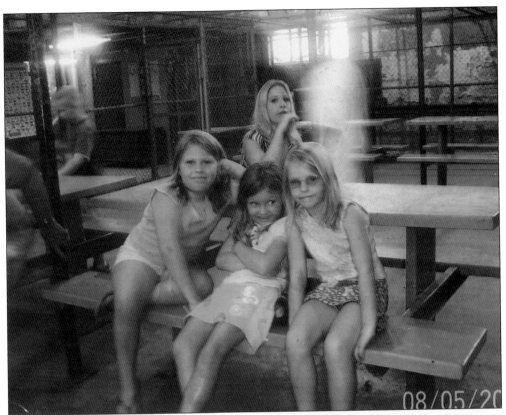

08/05/20

While attending the prison's daily tours, a group of children and a woman pose for a photograph in the cafeteria. The photograph captured what paranormal investigators refer to as an apparition seemingly walking behind the group wearing a white gown. (Courtesy of the Moundsville Economic Development Council.)

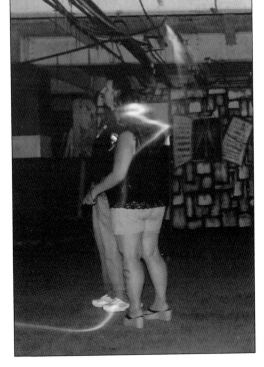

While attending a night tour, an unidentified couple was photographed exploring the Sugar Shack. An unexplainable orange light can be seen traveling along the floor and up towards the ceiling. (Courtesy of the Moundsville Economic Development Council.)

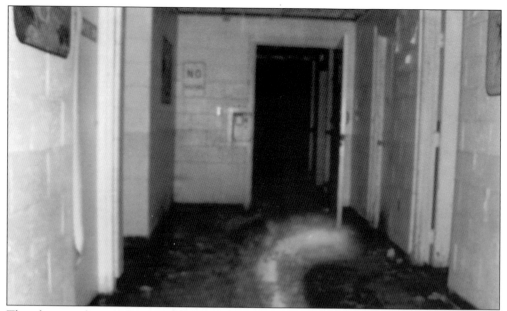

This photograph was taken in the hall of the medical ward by Nicole Myers. According to Myers, the group of four was experiencing difficulties with their camera, as if the batteries had drained; she was able to capture this image of an unexplainable orange light. According to paranormal experts, spirits require energy to manifest themselves, and batteries are an excellent source. This is why batteries often drain quickly in a paranormal environment. (Courtesy of the Moundsville Economic Development Council.)

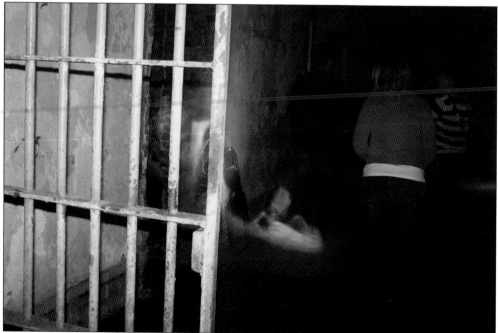

Perhaps the most disturbing tales come from those that have been harmed by unseen forces within the prison. Many visitors claim to have been pushed, grabbed, and even scratched by poltergeists. (Courtesy of the Moundsville Economic Development Council.)

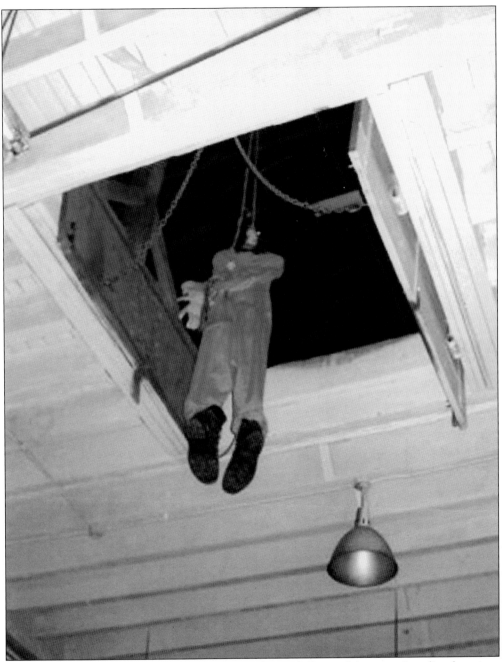

During the prison's commission, 85 inmates were hanged. Some of the prison's earliest hangings occurred in the North Wagon Gate, where many have witnessed the trap doors spring open inexplicably. Recalling his paranormal experience, former correctional officer Pat Davis says, "One night I was up in the North Wagon Gate, that's where the gallows was, where they hung people. All of a sudden I heard a boom. I went and I looked to see if somebody might have been hung on the door, but nothing was there. I didn't see nobody around, no light or anything, so I walked back out and all of a sudden BOOM! The gallows' doors were swinging open." (Courtesy of the Moundsville Economic Development Council.)

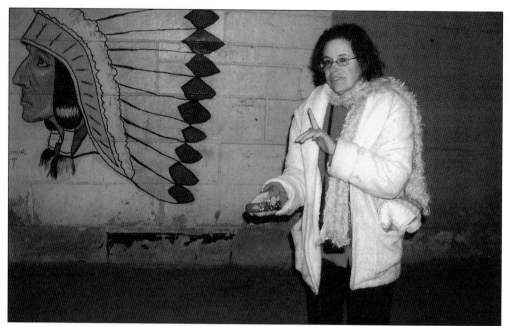

Paranormal investigator Jane Skeldon explores the Sugar Shack in search of paranormal activity. Skeldon is employing an electromagnetic field (EMF) detector to lead her towards paranormal activity. (Courtesy of Jason McKinney.)

North Hall is another area in the penitentiary where many experience high levels of paranormal activity. Due to the brutality that occurred within North Hall, the area was commonly referred to as "the Alamo" among inmates and staff. One afternoon in 1992, when officers opened the cell doors, inmate Russell Lassiter stormed into the cell of William "Red" Snyder and stabbed him 37 times with a shank. Many attribute the negative energy within the penitentiary to horrific events like these. (Courtesy of the author.)

The penitentiary had tales of haunting well before its closing in 1995. In the 1930s, guards would notice an inmate walking along the wall outside of the maintenance area; they would sound the alarm and investigate, only to find that no one was there. (Courtesy of Jason McKinney.)

The Sugar Shack provided indoor recreation for inmates in the event of poor weather conditions. Since this indoor recreation was unsupervised, many inmates took the opportunity to release sexual frustration and "get some sugar;" thus this area was nicknamed the "Sugar Shack" by inmates. Today, the Sugar Shack is said to be one of the most active areas for paranormal activity. (Courtesy of the author.)

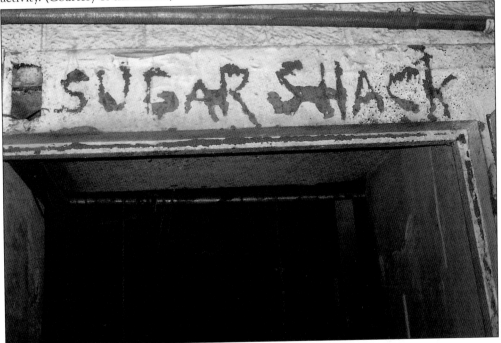

Jessica Nuckels and author Jonathan Clemins explore the Sugar Shack around 3:00 a.m. during the early morning of February 21, 2009, in hope of encountering signs of paranormal activity. Many refer to 3:00 a.m. as the "witching hour," during which time paranormal activity should be most active. This idea originates from the crucifixion of Jesus Christ. The belief is that Jesus' death occured at 3:00 p.m. Accordingly, the antithesis, 3:00 a.m. is when ghosts, spirits, and demons are supposed to be at their most active and powerful state. (Courtesy of Jason McKinney.)

The mere decorum of the penitentiary itself is enough to cause uneasiness. While exploring North Hall cell No. 9, messages such as "The Reaper is watching you" are enough to make anyone anxious, not to mention the sound of cells doors slamming shut inexplicably. (Courtesy of Jason McKinney.)

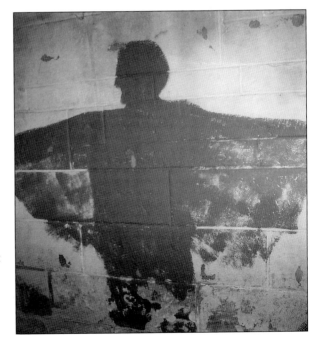

On September 10, 2000, MTV aired the first episode of *FEAR*, which was filmed at the West Virginia Penitentiary. The show consisted of a group of college-aged students who were assigned to complete dares within the penitentiary. If a contestant decided not to complete the dare, another would have to complete it. Once all dares were completed, the remaining contestants received $3,000. The painting in this photograph is located in the Sugar Shack but was not original inmate artwork. MTV decided that the artwork in the Sugar Shack was not frightening enough for the show and painted this image without the penitentiary's permission. Needless to say, MTV is no longer welcome. (Courtesy of the author.)

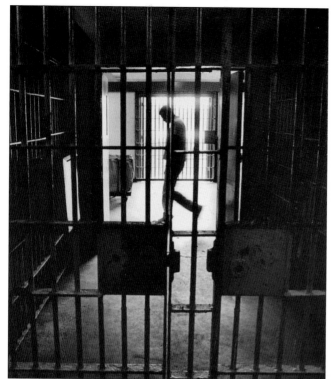

Across from the prison is an ancient burial mound for which the town of Moundsville was named. One legend states that the prison was built upon a burial mound similar to the one directly across from the prison. This is one explanation as to why the prison is such an active paranormal hotspot; however, there is no historical accuracy to the claim. (Courtesy of the *Charleston Gazette*.)

A legend that still resonates in Moundsville is that when inmates were executed in the electric chair, the city's lights would flicker on and off. This legend can be easily discredited as a myth, since the penitentiary operated completely from its own generator. (Courtesy of the *Charleston Gazette*.)

In an episode of the Travel Channel's *Ghost Adventures*, paranormal investigators lurked in the gloomy halls of the prison seeking proof of paranormal activity. While the group was investigating the prison they captured an electronic voice phenomenon (EVP) using a digital voice recorder. The audio evidence was analyzed by EVP specialists Mark and Debby Constantino. One of the most chilling EVPs recorded is apparently a voice proclaiming "I'll kill you!" (Courtesy of Jason McKinney.)

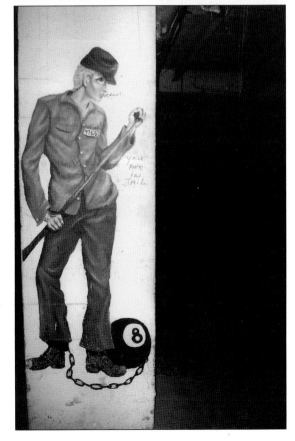

Perhaps one of the penitentiary's most haunting paintings is the inmate in the Sugar Shack. Preparing for a game of pool, inmate No. 47663, chained to a large 8-ball, seemingly stares back into the eyes of its audience. Some visitors feel as if the painting has a soul of its own. (Courtesy of the author.)

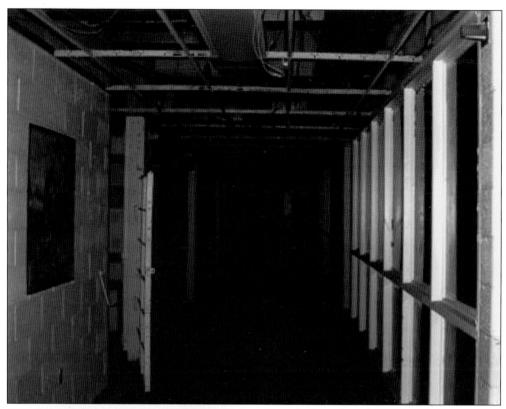

Many believe that the penitentiary is plagued by residual haunting. A residual haunting is a replay of a traumatic event from the past. Considering the violence, torture, and death that occurred at the penitentiary, this idea seems plausible. (Courtesy of Jason McKinney.)

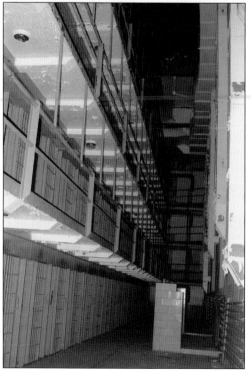

Roaming a dark and desolate cell block and hearing the unmistakable sound of cell doors slamming shut can intimidate the most courageous. By many accounts, this unexplained phenomenon has occurred on multiple occasions. (Courtesy of the Moundsville Economic Development Council.)

When inmates saw R. D. Wall having a conversation with the warden, they interpreted him as a snitch, or a rat in prison terms. To take care of the perceived rat, the inmates cornered Wall in the boiler room. Slowly, they tortured him by cutting off his fingertips, and eventually, they severed his head. This photograph depicts the room where Wall was brutally murdered. This area is one of the prison's hotspots for paranormal activity and is said to be haunted by Wall. (Courtesy of the author.)

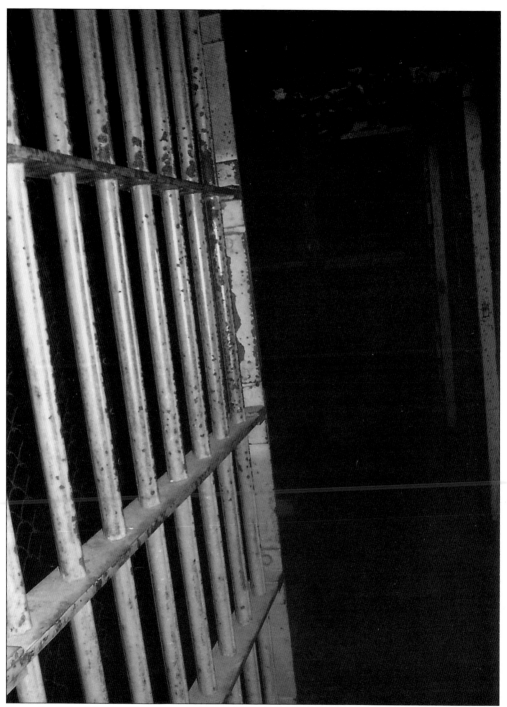

Does the West Virginia Penitentiary continue to imprison inmates? Do phantoms and unseen forces stalk the grounds of the penitentiary? Do astral beings preside over the prison? The answers to these questions are debatable. While many believe in paranormal phenomena, others are skeptical. Perhaps the best answer comes from those who have toured and experienced the penitentiary. (Courtesy of Jason McKinney.)

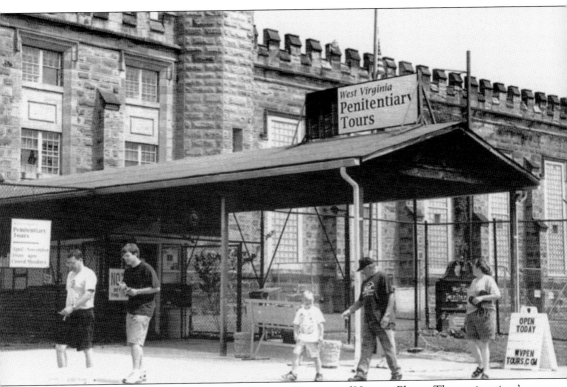

Today the penitentiary is represented on the National Register of Historic Places. The penitentiary's history and legends survive through the daily educational tours offered by the Moundsville Economic Development Council. Experience life behind bars and tour the penitentiary. While at the penitentiary, stop and listen. One may discover the voices of inmates and the intriguing stories they have to tell. (Restoration photography courtesy of Robert Schramm.)

BIBLIOGRAPHY

Boyd, P. *History of Northern West Virginia Panhandle*. Topeka, Indianapolis: Historical Publishing Company, 1927.

"Penitentiary Opens With Seven Inmates." *Moundsville Daily Echo*, August 30, 1935.

Schramm, R. W. Images of America: *Moundsville*. Charleston, SC: Arcadia Publishing, 2004.

"Under the Lash." The *Enquirer*, November 30, 1886.

Useem, B., and P. Kimball. *States of Siege: U.S. Prison Riots, 1971–1986*. New York: Oxford University Press. 1989.

Work and Hope Prison Magazine. *Souvenir of the West Virginia Penitentiary*. Moundsville: Moundsville West Virginia Print Shop, 1927.

Workman, M. E. "West Virginia Penitentiary, Prison History." Moundsville Economic Development Council. www.wvpentours.com/History.htm.

ABOUT THE ORGANIZATION

The Moundsville Economic Development Council offers day and night tours at the penitentiary. Families, groups, and schools come to the West Virginia Penitentiary to experience the chilling past of being locked up behind cold iron bars, hear the stories of former inmates and their deaths, and see the artifacts left behind, like "Old Sparky" (the electric chair used to execute nine inmates), an invitation to a public hanging, and officers' uniforms, weapons, and much more!

Learn more by visiting the prison's Web site at www.wvpentours.com and plan to visit one of the bloodiest penitentiaries in the history of the United States!

DISCOVER THOUSANDS OF LOCAL HISTORY BOOKS FEATURING MILLIONS OF VINTAGE IMAGES

Arcadia Publishing, the leading local history publisher in the United States, is committed to making history accessible and meaningful through publishing books that celebrate and preserve the heritage of America's people and places.

Find more books like this at
www.arcadiapublishing.com

Search for your hometown history, your old stomping grounds, and even your favorite sports team.

Consistent with our mission to preserve history on a local level, this book was printed in South Carolina on American-made paper and manufactured entirely in the United States. Products carrying the accredited Forest Stewardship Council (FSC) label are printed on 100 percent FSC-certified paper.

MADE IN THE USA